IMAGES
of America

NEW YORK CITY'S CHINESE COMMUNITY

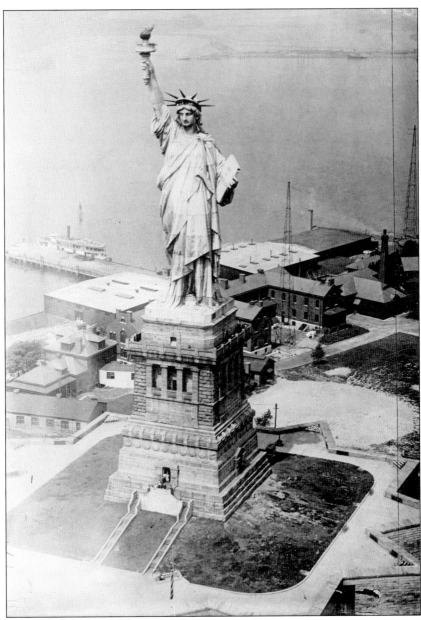

A United States Army plane photographed this aerial view of the Statue of Liberty. This statue, designed by sculptor Frederic-Auguste Bartholdi, is a symbol of freedom and democracy for people around the world. For many immigrants, including Chinese immigrants, the statue represents an opportunity for a new life. (Courtesy of the Library of Congress, Prints and Photographs Division.)

On the cover: Chinese American schoolchildren celebrate May Day in Central Park around 1913. To commemorate spring, they danced around maypoles, weaving in and out with the colored ribbons hanging from the tops of the poles. Many Chinese American children attended integrated schools and learned about many European traditions and festivals. (Courtesy of the Library of Congress, Prints and Photographs Division.)

IMAGES

of America

NEW YORK CITY'S
CHINESE COMMUNITY

Josephine Tsui Yueh Lee

ARCADIA
PUBLISHING

Published by Arcadia Publishing
Charleston SC, Chicago IL, Portsmouth NH, San Francisco CA

Printed in the United States of America

Library of Congress Catalog Card Number: 2007921340

For all general information contact Arcadia Publishing at:
Telephone 843-853-2070
Fax 843-853-0044
E-mail sales@arcadiapublishing.com
For customer service and orders:
Toll-Free 1-888-313-2665

Visit us on the Internet at www.arcadiapublishing.com

*Dedicated to the memory of my mother, Tsui So Mei (1944–1990).
She left a legacy of love, strength, and determination that
has been inspirational to all who knew her. Her bright
spirit continues to help guide the way.*

CONTENTS

ACKNOWLEDGMENTS

The idea for this book originated partly from my experience as a Chinese American living in the New York metropolitan area. I speak Cantonese and have traveled throughout Asia, including Hong Kong. While most of my family lives in New York, I still have relatives living in China who regularly visit New York.

Years ago, my aunt reminisced about old times while looking through old photographs and said that someone should write a book about my late grandmother's sacrifices in China and in New York. My late grandmother's experiences are part of the rich history shared by thousands of Chinese Americans. This book's initiative further developed as a result of my interactions and discussions with many Chinese Americans who lived and worked in New York.

Many people supported my efforts to better understand this community. They kindly shared their stories. It is impossible to name everyone individually, but without their wealth of knowledge, this book would not have been possible. Their support with identifying places and events helped weave together the stories behind the images.

I am fortunate for the honest critique from Elizabeth Brown, a member of the Asian American Journalists Association. Sincere thanks go to Ann Meehan for her valuable feedback. Thanks also go to the National Archives Records and Administration New York staff for pulling out the Chinese Exclusion Act files, documents rich with local history.

I appreciate the following people for giving me permission to tell their stories and to publish photographs from their personal archives: Tulien Aizawa, Elizabeth Brown, Maria Luisa Burley, Chei Lang Chian, Edison Chu, Chu-Ching Hu, Sonia Kuenzig, Thomas Lee, Benito León, Kwong Yuen Leung, councilman John Liu, and Tan Dun, Jane Huang and Parnassus Productions.

Finally, special thanks go to my husband, Joseph Moore Jr., whose love and encouragement helped make this book a reality.

INTRODUCTION

The history of New York City's Chinese community started around the 19th century. Chinese immigrants came here to find opportunities to build better futures for their families. According to United States Census Bureau data, nearly 40,000 immigrants from China arrived in the United States in 1882. However, an economic depression in the late 1800s caused high unemployment across the nation. This triggered white American laborers to believe that Chinese immigrants were taking away their jobs. Newspaper articles and cartoons in magazines perpetuated anti-Chinese sentiment.

The United States government responded by ratifying the Chinese Exclusion Act in 1882. The Chinese Exclusion Act suspended the immigration of Chinese laborers. Chinese immigrants needed to prove that they were merchants, teachers, or students in order to come to America. As a result, the number of immigrants from China shrank to a small few during the next 85 years. In 1887, the number of immigrants from China reached a low of merely 10 people. In the 1960s, the United States government passed new legislation allowing a greater number of Chinese immigrants to come to America. In 2004, the number of immigrants from China reached more than 50,000 people.

In the early years, Chinese immigrants mainly came to New York City directly from China. Most of these Chinese immigrants were men. They bought third-class tickets and traveled in packed steerage areas on ships bound for the United States. In the early 1900s, a third-class ticket on a ship cost about $5, an enormous amount of money for a Chinese immigrant to pay for his journey to New York City.

When a Chinese immigrant arrived at Ellis Island, doctors conducted a physical examination to make sure that he did not have any health problems, and immigration officials asked detailed questions about his family's background. The questioning sessions lasted many hours and sometimes dragged on for weeks and months. Thousands of pages of transcripts documented these extensive proceedings. By the middle of the 20th century, Chinese immigrants began arriving in airplanes instead of on ships. These immigrants had more diverse backgrounds and came from various places besides China, including Taiwan, Hong Kong, Brazil, Mexico, France, the Philippines, and Vietnam.

Strong family ties linked Chinese immigrants with their relatives back in their homelands. Many Chinese immigrants wrote letters telling the relatives that they had left behind about their new lives in New York City. In addition, they sent money back home to help care for family. After saving enough money, they would bring other family members to live with them in New York City.

The challenges Chinese immigrants faced when they reached New York City were similar to those of other immigrants. They encountered a foreign language as well as new customs, new foods, new clothing styles, and new living arrangements. Learning English was particularly difficult. Unlike the English language, the Chinese language uses characters instead of letters of an alphabet. Furthermore, some complexities found in the English language do not exist in the Chinese language. Unlike nouns in English, nouns in Chinese do not have singular and plural forms. In addition, only one pronoun exists in Chinese while pronouns in English have feminine, masculine, singular, and plural forms. Moreover, Chinese verbs do not need to be conjugated, while English verbs need to be conjugated into singular and plural forms as well as into numerous tenses such as present, past, future, and past perfect.

Chinese immigrants did find some comfort in their ethnic neighborhoods. Chinese storefronts filled the sidewalks with fresh fruits, green vegetables, and fish from that morning's catch. Chinese sausages hung on display in shop windows. These familiarities reminded them of their homelands.

In the midst of extremely difficult circumstances, Chinese Americans showed tremendous strength and courage in building their families, starting new careers, and setting up roots in new communities. Motivated by hopes of better lives for their families, they overcame tough obstacles. Like other immigrants, Chinese immigrants worked hard to make a living for their families. They strove to retain valued cultural traditions passed onto them over many generations while also adopting new ways of life. Their cultural heritage, their motives behind leaving China, their passage to New York City, the personal changes they made to their lives in the United States, and their contributions to their new communities have helped create the unique characteristics of New York City.

The integration of Chinese Americans into life in New York City varied individually. Some Chinese Americans who preferred to be in predominantly Chinese neighborhoods lived in one of five Chinatowns in New York City. The original Chinatown is located in Manhattan, while the newer Chinatowns are located in the Sunset Park and the Avenue U–Marine Park sections of Brooklyn and in the Flushing and Elmhurst neighborhoods of Queens. Other Chinese Americans settled in various neighborhoods in New York City, including the Upper East Side, the Upper West Side, Brooklyn Heights, Park Slope, and Staten Island.

Some Chinese Americans who spoke little English preferred to work for Chinese employers or started their own small businesses. Chinese restaurants, Chinese laundries, and Chinese retail stores on Mott Street and Doyers Street provided these job opportunities. Newer generations either took over their parents' family businesses or attained higher educations at colleges and universities. Many holding college degrees became specialists and obtained professional jobs in fields such as law, medicine, and business.

Some Chinese American parents felt obligated to teach their children Chinese values and beliefs. They enrolled their children in Chinese-language school in order to help their children retain their Chinese cultural heritage. Shaped by the teachings of Confucius, they highly valued academics and intellectual thought. Therefore, they urged their children to achieve college degrees from top universities.

Raising their children in New York City, many Chinese American parents were inundated with American influences. Some adopted Christianity and sent their children to Sunday school, while others simply celebrated Christmas and Easter as occasions to spend time with family. Many continued to stir-fry bok choy in a wok, but also substituted broccoli for variety. Many carried on the tradition of exchanging moon cakes during Harvest Moon Festival, but also embraced gift-giving during Christmastime. The traditions of old China began to blend with the customs of new America. The definition of the Chinese American family continues to evolve.

Several recent films shed some color on the Chinese American experience. Georgia Lee's *Red Doors* (2005) illustrated the friction between the new and old ways of life of several generations of Chinese Americans. Ang Lee's *The Wedding Banquet* (1993) depicted a Chinese American man conflicted with his American life and his Chinese inner feelings of devotion to his family.

Wayne Wang's *The Joy Luck Club* (1993) told the stories of a group of Chinese American women dealing with cultural changes and established family ties.

Chinese Americans play an important part in American society, including the New York City area. Without the accomplishments of Chinese Americans, New York City would not be the same city that we have come to know today. New York City's Chinese Americans have not only influenced their local communities, but have dramatically changed many disciplines. Their achievements and contributions have helped establish legacies. These ethnic Chinese New Yorkers include Grammy award-winning composer Tan Dun, Tony award-winning actor Bradley Darryl Wong, groundbreaking AIDS research scientist David Ho, talented fashion designer Vera Wang, Tony award-winning playwright David Henry Hwang, Grammy award-winning cellist Yo-Yo Ma, and distinguished food writer Grace Young.

One

COMING TO AMERICA

The history of Chinese immigration to the United States saw two significant phases. The first period was in the late 1800s, after the enactment of the Chinese Exclusion Act. The second was in the late 1960s, after the elimination of country immigration quotas.

During the economic depression of the late 1800s, anti-Chinese sentiment prevailed. In 1882, Congress passed the Chinese Exclusion Act and suspended the immigration of Chinese laborers. This limited the growth of Chinatown in New York City.

The Chinese immigrants who met the criteria of being merchants, teachers, or students endured long trips on ships from China to the United States. Upon their arrival at Ellis Island, Chinese immigrants experienced extensive questioning about their home villages and family history. Hundreds of pages of immigration records and photographs documented this tough process.

In 1943, Pres. Franklin Delano Roosevelt repealed the Chinese Exclusion Act. After more than 60 years, the United States government allowed Chinese people to enter America again. However, the government still placed Chinese immigration under quota. Feelings in this country about Chinese people radically improved, and the elimination of country immigration quotas in 1965 encouraged Chinatown's expansion.

Initially Chinese immigrants had settled mostly on Mott Street, Pell Street, Christie Street, and Bayard Street. The heart of Chinatown remains on Mott Street, but Chinatown's borders have spread way beyond just a few streets. In addition, Chinese immigrants began settling in other parts of New York City. Eventually they established Chinatowns in Brooklyn and Queens.

During the late 1960s, New York City's Chinatowns attracted more than just Chinese immigrants from China. They also attracted Chinese people from around the world. In order to break away from their difficult lives in China, these more recent Chinese immigrants had left China and settled initially in various parts of the world. To find more opportunity for their families, they later came to the United States and settled in New York City. Today New York City has the largest concentration of Chinese Americans in the United States.

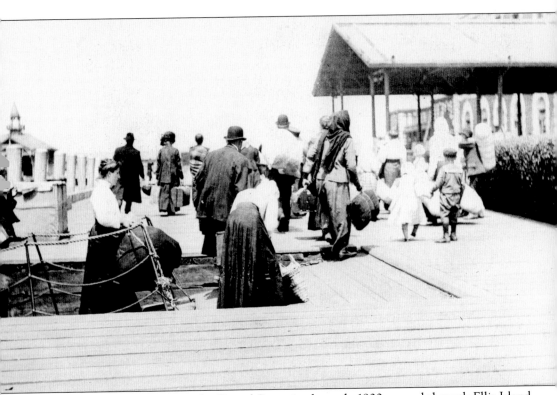

Many immigrants arriving to the United States in the early 1900s passed through Ellis Island, located in New York Harbor, off the coast of New Jersey. Through the years, this dock received countless immigrants, including Chinese immigrants. First- and second-class passengers were not required to be inspected at Ellis Island. According to the Statue of Liberty-Ellis Island Foundation, these well-heeled passengers endured only a superficial inspection aboard ship and were free to enter the United States after passing through customs. They were sent to Ellis Island for further inspection only if they were sick or had legal problems. The steerage and third-class passengers, however, were brought by ferryboat to Ellis Island to undergo medical and legal inspections. The examination took three to five hours if an immigrant's papers were in order and his health was fairly good. However, a Chinese immigrant's interrogation often lasted many days, weeks, or even months. If an immigrant was diagnosed with a contagious disease, he would be denied entry into the United States. (Courtesy of the Library of Congress, Prints and Photographs Division.)

Hom Goon Pon (left) lived in Chinatown. Since he was a native of the United States, his son Hom Din (center) came into the United States as a citizen. Choy Ng (right) was the identifying witness in the application for the admission of Hom Din to the United States. (Courtesy of the U.S. National Archives and Records Administration.)

Hom Din came to the United States in 1922 on a ship via Vancouver and was admitted to Ellis Island. Born in Canton, China, Hom Din grew up in San Hung Mee, a village in the Hok Shan district. The village had only three houses. Hom Din settled in Chinatown and became a laundry proprietor in Jamaica, a neighborhood in Queens. (Courtesy of the U.S. National Archives and Records Administration.)

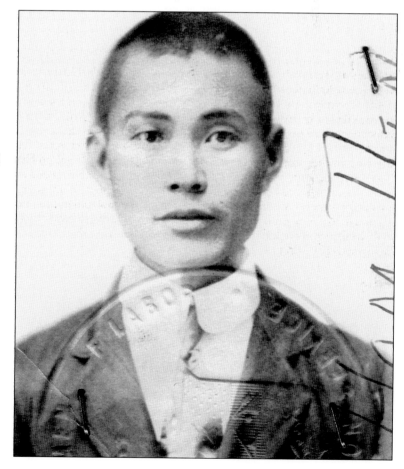

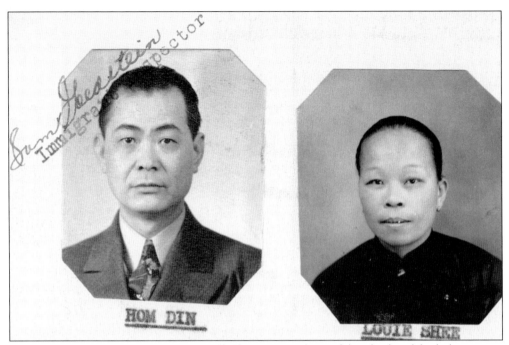

Louie Shee (right) married Hom Din (left) in 1915. She and her husband had three sons. She was born in Tung Mee, a village in the Hok Shan district, and later lived in Hong Kong before immigrating to New York City. (Courtesy of the U.S. National Archives and Records Administration.)

Lee Yum grew up in Lung Won, a village in the Sun Wey district. He came to the United States in 1880 and managed a restaurant in New York City. He invested $1,000 to be one of 23 partners in the Bond Wah Restaurant and earned $130 per month as a restaurant manager. (Courtesy of the U.S. National Archives and Records Administration.)

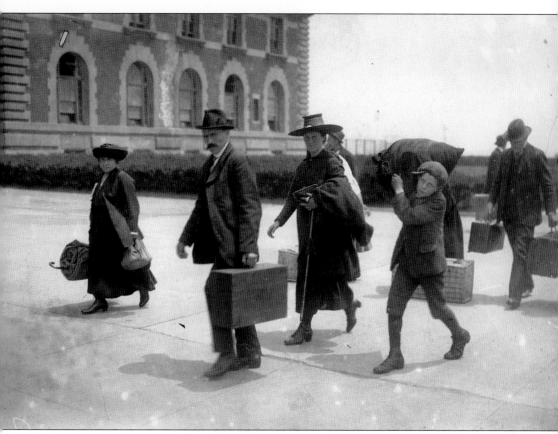

Emigrants pictured here arrived at Ellis Island in 1907. They passed through to a landing after disembarking a ferryboat. Ferryboats brought them from Ellis Island to the Battery. The government agencies responsible for processing immigrants at Ellis Island were the United States Public Health Service and the Bureau of Immigration. Health inspections took place at Ellis Island in the Registry Room, or Great Hall. According to the Statue of Liberty-Ellis Island Foundation, doctors became very skilled at performing these physical examinations and recognized various medical conditions simply by taking a quick look at an immigrant. Interrogators asked Chinese immigrants hundreds of detailed questions such as "Describe your home village" and "Who occupies these houses?" Today three bureaus within the U.S. Department of Homeland Security are responsible for processing immigrants: the Bureau of Citizen and Immigration Services, Bureau of Immigrations and Customs Enforcement, and Bureau of Customs and Border Protection. (Courtesy of the Library of Congress, Prints and Photographs Division.)

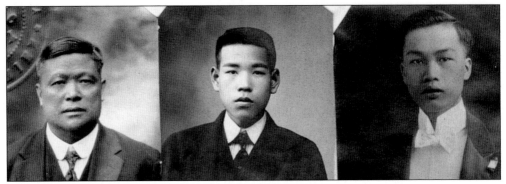

Lee Go (center) arrived in 1923 on the ship S.S. *President Jefferson* to Seattle en route to his father, Lee Yum (left), in New York City. He was detained due to disease. He had paid for his own third-class ticket, which cost $5. The identifying witness in the application for his admission to the United States was Lee Yick (right). (Courtesy of the U.S. National Archives and Records Administration.)

Some immigrants who arrived on this dock at Ellis Island were sent to the new hospital building on Ellis Island, the quarantine buildings on Swinburn Island, or Hoffman Island. All suspects were transferred to Swinburn Island to await any disease development. Immigrants afflicted with contagious diseases were sent to Hoffman Island. (Courtesy of the Library of Congress, Prints and Photographs Division.)

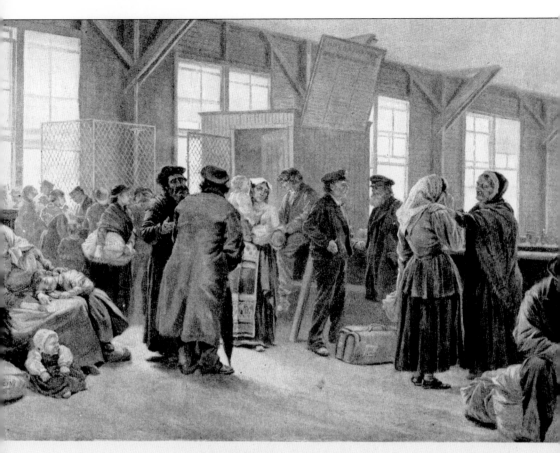

DETAINED IMMIGRANTS ON ELLIS ISLAND, NEW YORK HARBOR.—Drawn by M. Colin.

Emigrants with disease were not admitted to the United States. M. Colin's drawing of detained immigrants on Ellis Island in New York Harbor was illustrated in *Harper's Weekly* in 1893. The detention pen, on the roof of the main building on Ellis Island, held emigrants for deportation. Because ships could not leave in bad weather, the rejected individuals waited for better weather to return back to their home country. The doctors for the United States Public Health Service diagnosed some Chinese immigrants with clonorchiasis, also known as Chinese liver fluke. They considered clonorchiasis a dangerous, incurable, and contagious disease. Therefore, doctors would refuse admission to the United States to immigrants diagnosed with the disease and deport them back to China. Clonorchiasis, common in Asia, is caused by eating infected fish. According to the Center for Disease Control, cases have been reported in the United States. These cases occurred among Asian immigrants and people who had eaten imported products contaminated with infected fish. Doctors have been treating this infection with medication. (Courtesy of the Library of Congress, Prints and Photographs Division.)

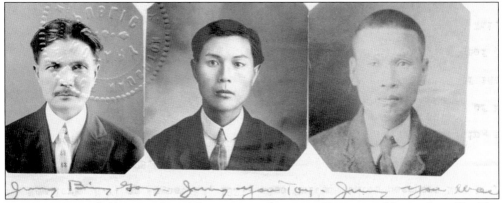

Jung Bing Qong (left) was a United States citizen living in Chinatown. His son Jung You Toy (center) arrived to New York City in 1922 as a son of a citizen. Jung Bing Qong and his wife had four other sons: Jung You Wai (right), Jung You Gay, Jung You Jen, and Jung You Thung, who were farmers in China. (Courtesy of the U.S. National Archives and Records Administration.)

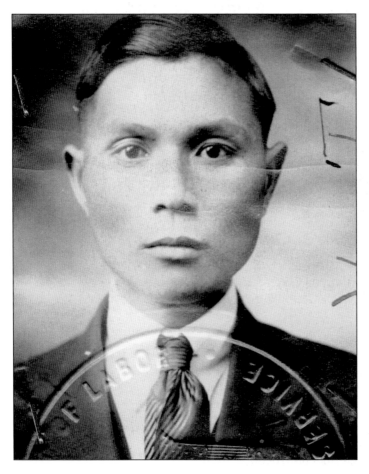

In 1922, Jung You Toy arrived to the port of New York on the ship S.S. *Silvia*. He was from the Dai Hing village. His wife, Ng Shee, was from the Soon Suey village. They had three sons. Jung You Toy became a laundryman and lived in Brooklyn. (Courtesy of the U.S. National Archives and Records Administration.)

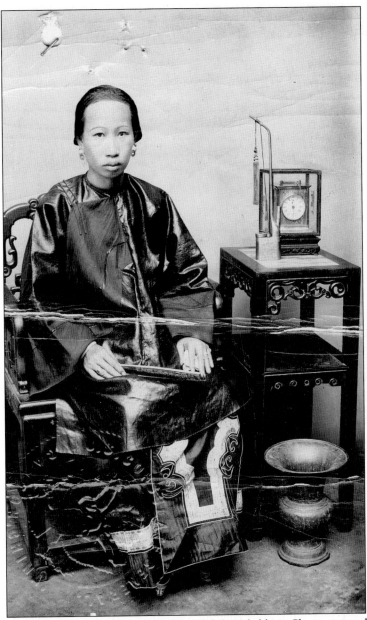

In 1906, Chin Hon Sze arrived to New York City with her children. She is pictured here dressed in traditional silk clothing. Her husband, Chu Hoy, was a merchant in Chinatown. Chu Hoy was born in Canton, China, and grew up in the Har Low village. In 1882, he arrived to San Francisco. After living in San Francisco as a student, he moved to New York City. Initially he became a laundryman. Later on, he invested $1,500 to become a merchant of Kwong Sung Chung and Company, a clothing business on Mott Street. Since Chu Hoy was from Canton, he most likely spoke Cantonese. According to the *Practical Chinese Reader*, there are eight major Chinese dialects and thousands of minor Chinese dialects of the Chinese language. These dialects, spoken in different regions, share the same written characters. However, speakers of any one of these dialects cannot understand any of the other dialects. (Courtesy of the U.S. National Archives and Records Administration.)

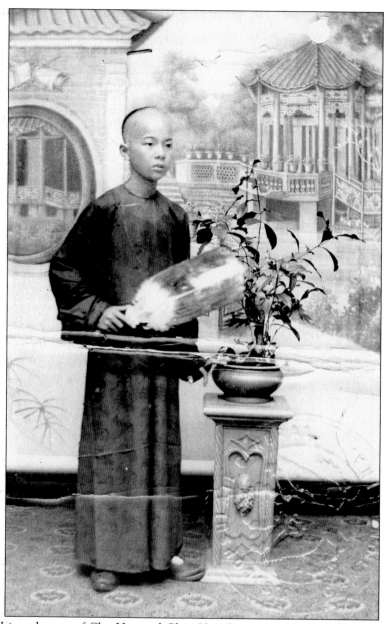

Chin A. Hsiao, the son of Chu Hoy and Chin Hon Sze, immigrated to New York City from China in 1906. He is pictured here dressed in a traditional long silk tunic, a one-piece garment. Later on, Chinese people generally wore Western-style clothing. Chin Hsiao's fan was made from feathers. Chinese fans were also made from silk, bamboo, straw, bones, leaves, and paper. Chinese people have been using handheld fans to cool themselves since the ancient times. These fans served a functional and decorative purpose. Chinese fans had various shapes and often were decorated with calligraphy, drawings, or embroideries of birds, flowers, or landscapes. Chinese artists also created paintings for large screens. The screen painting in the background depicted the pagoda-style architecture characteristic of buildings found in China. In addition to mounting paintings on fans and screens, Chinese people also mounted paintings on scrolls. (Courtesy of the U.S. National Archives and Records Administration.)

Chin Po Cum, the daughter of Chu Hoy and Chin Hon Sze, immigrated to New York City from China in 1906. She is pictured here dressed in traditional silk clothing. Her fan was made from stretched silk over a round frame and decorated with drawings. (Courtesy of the U.S. National Archives and Records Administration.)

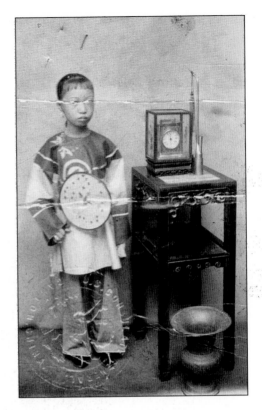

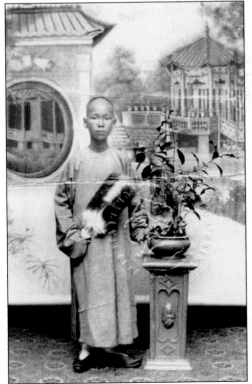

Hong Ah Kit, the adopted son of Chu Hoy and Chin Hon Sze, immigrated to New York City in 1906. He is pictured here dressed in a traditional long silk tunic and holding a fan made from feathers. Birds such as eagles, peacocks, geese, owls, and cranes provided the feathers for the fans. (Courtesy of the U.S. National Archives and Records Administration.)

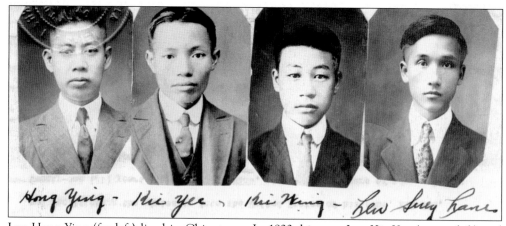

Hong Ying – Kie Yee – Kie Wing – Lew Suey Lane

Lau Hong Ying (far left) lived in Chinatown. In 1923, his sons Lau Kie Yee (center left) and Lau Kie Wing (center right) arrived from China on the ship S.S. *Rosalind*. Lau Suey Len (far right) was the identifying witness for their admission to the United States. (Courtesy of the U.S. National Archives and Records Administration.)

Lung Yew, born in San Francisco in the late 1800s, had three sisters and one brother. He moved to New York City at age five, lived in Chinatown, and became a laundryman. His father's name was Leung Bit. The same Chinese family surnames were often spelled differently due to variations in different interpreters' English phonetic translations. (Courtesy of the U.S. National Archives and Records Administration.)

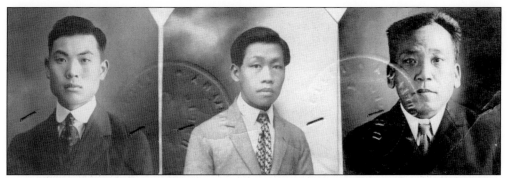

Luck Ah Sing (right), an American-born citizen, lived in Chinatown. He worked in a laundry. His brother Luck Lung Shang (left) served as the identifying witness for the admission of Luck Leung Chew (center) to the United States. Luck Leung Chew came to New York City in 1922 from the Gook Sung village on the ship S.S. *Sylvia*. (Courtesy of the U.S. National Archives and Records Administration.)

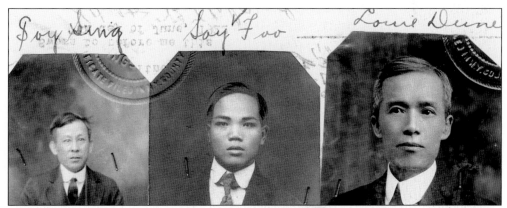

Soy Sing (left), born in the United States, lived in Chinatown. Louie Dune (right) served as the identifying witness for the admission of his son Soy Foo (center) to the United States. Soy Foo grew up in the Ai Hong village, consisting of only six houses. In 1922, Soy Foo arrived in New York City on the ship S.S. *Rosalind*. (Courtesy of the U.S. National Archives and Records Administration.)

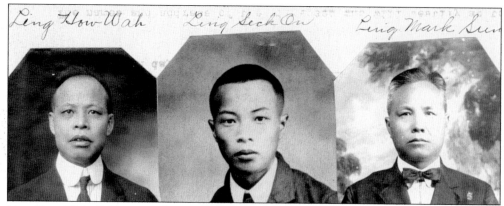

Ling How Wah (left), a merchant of Mess, Quin Wo, and Company in Chinatown, earned only $80 per month. In 1922, he applied for admission of his minor son Ling Seck On (center) to the United States. Ling Mark Sun (right) testified to the father and son relationship. Two non-Chinese men were required to testify to Ling How Wah's mercantile status. (Courtesy of the U.S. National Archives and Records Administration.)

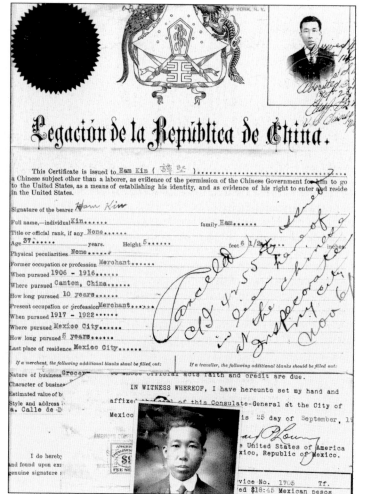

Ham Kin, born in the Bak Suey village, was a grocer for 10 years in Canton, China, before he immigrated to Mexico City, Mexico. In Mexico, he ran the grocery store El Asia. The Chinese Consulate in Mexico issued this certification of his merchant status. In 1922, he immigrated to the United States and settled in Chinatown. (Courtesy of the U.S. National Archives and Records Administration.)

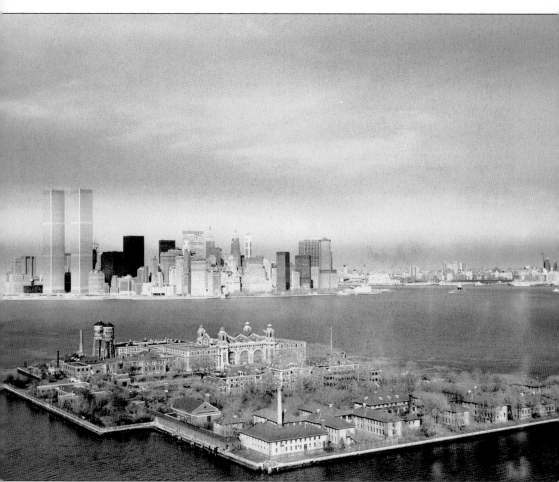

Ellis Island served as a federal immigration station from 1892 to 1954. It is now part of the National Park Service's Statue of Liberty National Monument. According to the Ellis Island-Statue of Liberty Foundation, Ellis Island is one of the most popular tourist destinations in the National Park Service. The Ellis Island Immigration Museum receives more than three million visitors each year. Through the years, the original 3.3-acre site was enlarged to 27.5 acres with landfill possibly from earth excavated for the construction of the New York City subway system. Visitors can walk through the Great Hall, where millions of immigrants, including Chinese immigrants, had to pass inspections in order to enter the United States. This aerial view of Ellis Island in New York Harbor looks east toward the Manhattan skyline with the World Trade Center in the background on the left. (Courtesy of the Library of Congress, Prints and Photographs Division, Historic American Buildings Survey.)

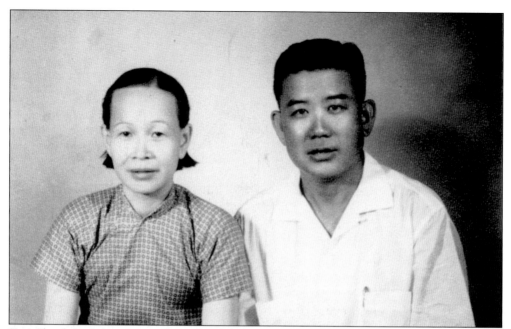

Tsui Chenk (right) immigrated to several different places before arriving in New York City. He fled from China in the 1940s to Macau, then to Hong Kong, then to Brazil, and finally to the United States. He worked as a dishwasher in a Chinese restaurant in Chinatown. His and his wife, Leung Yip Sheng (left), lived in Manhattan's Chinatown. (Courtesy of Elizabeth Brown.)

Leung Yip Sheng lived in this small village in the Enping district in southeastern China. She spoke the Enping dialect, the language of that region. She immigrated to New York City in the 1970s and worked as a thread trimmer at a garment factory in Chinatown. (Courtesy of Thomas Lee.)

Unlike the earlier Chinese immigrants who came from villages in China, many of the Chinese immigrants during the 1960s and 1970s came from other places in the world, such as Taiwan, Hong Kong, Vietnam, Mexico, and Brazil. Szu Hsiung Chu (right) and Yu Man Chu (left) immigrated to the United States from Taiwan. Their son Edison works in finance in New York City. (Courtesy of Edison Chu.)

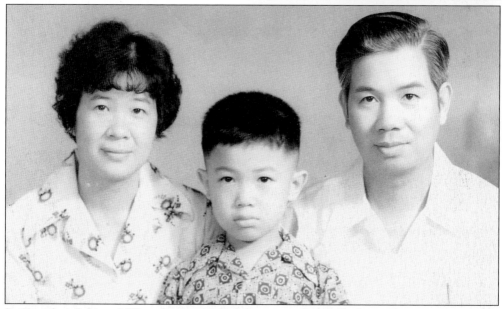

So Kit Chui (left) and Wing On Leung (right) emigrated initially from China to Hong Kong. Shortly after their son Kwong Yuen Leung (center) started to attend school, they immigrated to New York City in the 1970s and settled in an apartment on the Lower East Side. The borders of Chinatown expanded into this neighborhood where Jewish immigrants had lived historically. (Courtesy of Kwong Yuen Leung.)

Su Ping Chui (left) immigrated to Mexico from China and married Ricardo León (right). Ricardo was born in Mexico, but Ricardo's father immigrated to Mexico from China. Su Ping and Ricardo owned a Chinese grocery store in Mexico. They eventually immigrated to New York City from Mexico and started a garment factory. (Courtesy of Benito León.)

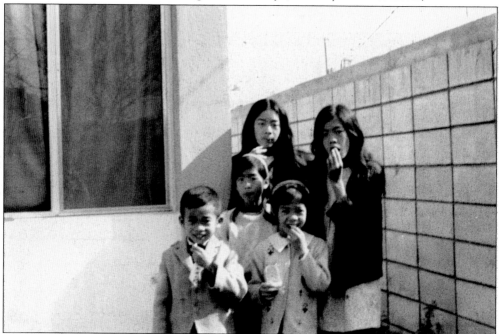

Su Ping and Ricardo León's family included five children. Pictured here outside of their home in Mexico from left to right are (first row) Benito León, Rosalba Chez, and Sonia Kuenzig; (second row) Ana León and Maria Luisa Burley. After they immigrated to New York City, they lived in Manhattan's Chinatown and Brooklyn's Chinatown. (Courtesy of Benito León.)

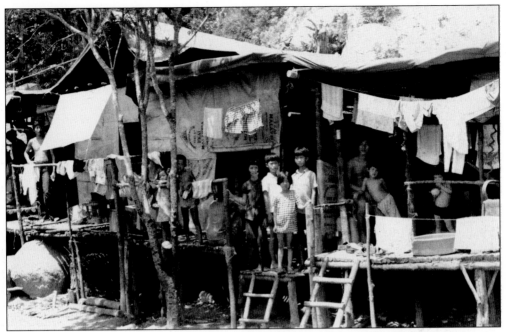

Tulien Aizawa plays with other children at a refugee camp in Malaysia. She fled from Vietnam to Malaysia and eventually immigrated to New York City. She and her family settled in Brooklyn. Like many other Chinese Vietnamese families, her grandparents had immigrated initially to Vietnam from China for business. (Courtesy of Tulien Aizawa.)

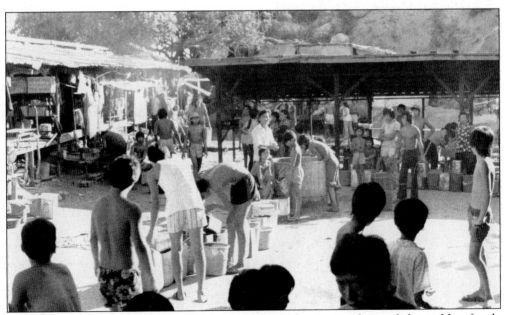

Tulien Aizawa lived at this refugee camp in Malaysia for six months until she and her family could immigrate to New York City. People here obtained water from a well because the camp did not have running water. After hand-washing clothes, they hung laundry to dry. (Courtesy of Tulien Aizawa.)

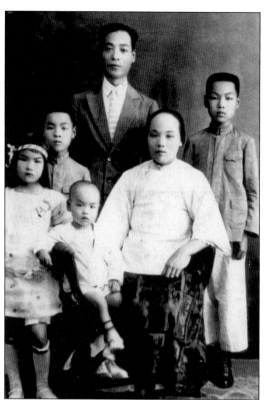

Chu-Ching Hu's grandmother (far left) stood for a photograph with her family in China in 1925. Their clothing styles reflected a blend of Chinese and Western cultures. Chu-Ching was born in Paris and grew up in the United States. She lives and works in New York City. (Courtesy of Chu-Ching Hu.)

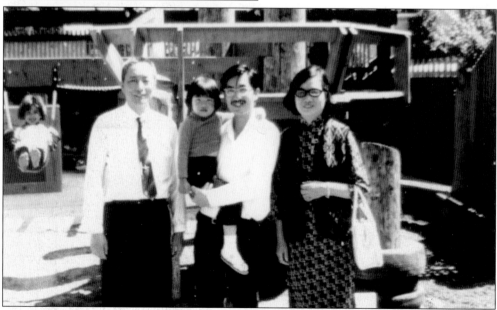

Chu-Ching Hu's grandparents, father, and elder sister visit a playground in France. Chu-Ching's grandparents moved from China to Hong Kong after the Chinese revolution. Her father studied in the United States. After he received his doctorate in physics, he pursued postdoctoral study in Paris. Chu-Ching and her family immigrated to the United States from France. (Courtesy of Chu-Ching Hu.)

Chu Ching Hu's grandfather was a young cadet in the military for his homeland. The Chinese military strategy in *The Art of War*, written more than 2,000 years ago by Sun Tzu, is widely read today. The philosophy behind these Chinese war tactics is being applied by business people to corporate situations. (Courtesy of Chu-Ching Hu.)

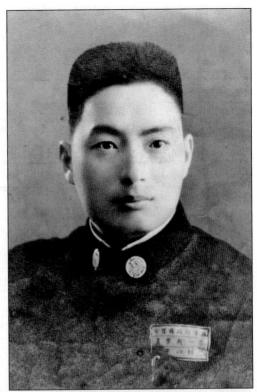

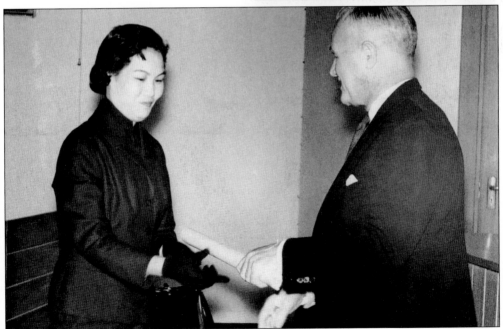

Chinese traditional beliefs emphasized the importance of higher education. Doctors of medicine, in particular, were held in high esteem. Chu-Ching Hu's grandmother (left) received her medical license in Hong Kong. Previously she attended a top German medical college in China. She was fluent in Chinese, German, and English. (Courtesy of Chu-Ching Hu.)

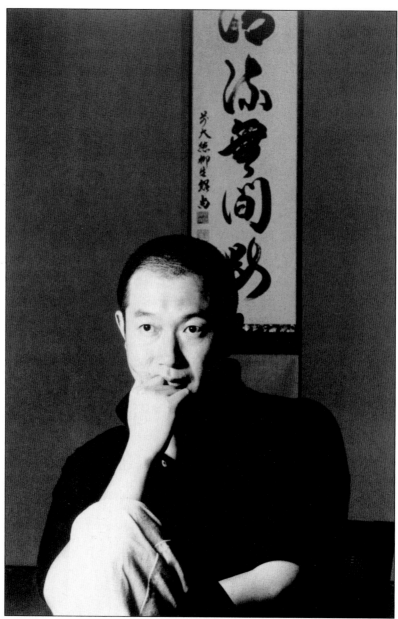

Tan Dun grew up with his grandmother in a rural village in Hunan, China. During the Cultural Revolution, he worked as a rice planter in China. Before he left China to study music at Columbia University, he had already become recognized in China for his music. His musical compositions have integrated both Eastern and Western influences. He has written a wide variety of work, such as operas, symphonies, film soundtracks, chamber music, violin compositions, choral music, and piano concertos. He has become a highly acclaimed international composer and conductor. Leading orchestras and opera houses throughout the world, including the New York Philharmonic, the Berlin Philharmonic, and the Metropolitan Opera, perform his works. His musical score for the film *Crouching Tiger, Hidden Dragon* earned him both a Grammy award and an Academy Award. He was also awarded the prestigious Grawemeyer Music Award for Composition in 1988. (Courtesy of Tan Dun, Jane Huang and Parnassus Productions.)

Two

CELEBRATION OF THE CHINESE NEW YEAR

Chinese New Year is the most important holiday of the Chinese calendar. Although Chinese people follow the solar calendar today, they still use the lunar calendar to observe Chinese holidays. The celebration of Chinese New Year in New York City is a major event. The two-week celebration involves many traditions and superstitions. Anticipation and enthusiasm precede the start of Chinese New Year, year after year.

The streets of Chinatown are decorated with red lanterns and red streamers, and a lion dance welcomes the Chinese New Year. People throw firecrackers in the streets until the debris of red paper wrappers blankets the sidewalks and smoke fills the air. The color red, which promotes prosperity, is everywhere.

For many Chinese Americans, this is an occasion to honor the sacredness of family. In the Chinese culture, profound respect for age has been a very important tradition. Typically the younger Chinese people visit their elders first during Chinese New Year. Individuals visiting family and friends for Chinese New Year pack Chinatown. Boys and girls wear beautiful new silk clothing to make New Years calls with their parents. Family and friends exchange *lai see* (small gifts of money sealed in red envelopes).

In some Chinese American homes, pyramids of oranges, tangerines, and pomelos decorate kitchen tables and television sets. These fruits symbolize good luck, happiness, and wealth. On New Year's Day, some Chinese families eat *jai* (a vegetarian dish) for dinner. The recipe for jai includes *gum zhum* (lily buds) and *fat choy* (black dried moss). These ingredients symbolize prosperity for the upcoming year. The Chinese words for lily buds translates to mean "golden needles" and the Chinese words for black dried moss sound like the Chinese words that mean "becoming prosperous." During the celebration, they also eat New Year's cakes, such as *low bock gow* (Chinese turnip cake), *woo tul gow* (taro root cake), *fat gow* (prosperity cake), and *nian gow* (New Year's cake). The Chinese word for cake sounds like the Chinese word for high. Therefore, eating cakes symbolized increased fortune and higher advancement and would promote prosperity in the upcoming year.

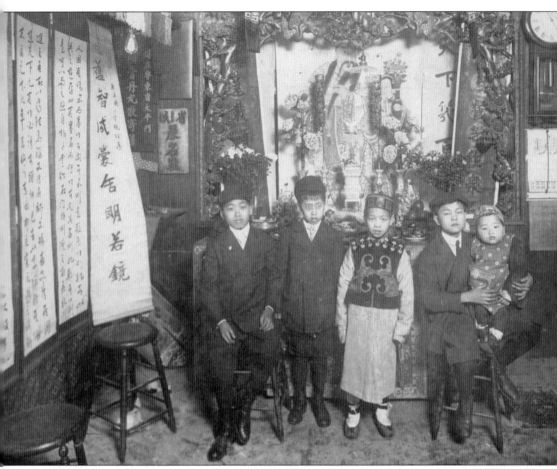

Five boys wearing their best clothes celebrate Chinese New Year in Chinatown in 1911, the Year of the Pig. Chinese New Year is the most important traditional Chinese holiday. Red scrolls with writing in black ink hang on the walls of many homes and businesses throughout the festivities. These decorations bear messages of good luck, long life, and happiness for the upcoming new year. Paper-cuts, figures cut from paper, adorn doors and windows. Flowers, such as the plum blossom and the narcissus, also decorate homes. These traditional lucky flowers symbolize longevity and prosperity and are sold a few days before New Year's Day at the Lunar New Year Flower Market at Columbus Park in Manhattan's Chinatown. Many Chinese people burn incense in their homes or at temples to pay respect to their ancestors. Remembering relatives who have passed away acknowledges the people who established the past and present generations of their family. (Courtesy of the Library of Congress, Prints and Photographs Division.)

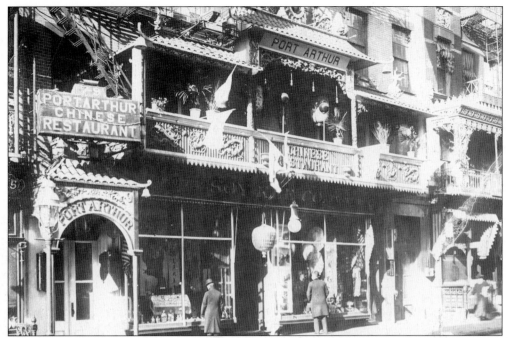

The Port Arthur Chinese Restaurant on Mott Street in Chinatown is decorated for Chinese New Year. The Port Arthur Chinese Restaurant was named for a city located on the northeastern coast of China. Many banquets were held at Port Arthur Chinese Restaurant, one of the largest Chinese restaurants in Chinatown. (Courtesy of the Library of Congress, Prints and Photographs Division.)

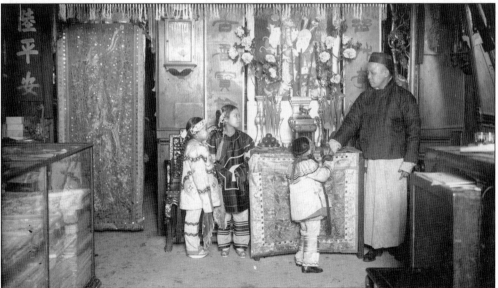

A Chinese family celebrates Chinese New Year's Day in Chinatown. The Chinese New Year celebration starts on the first day of the lunar calendar, which corresponds to a date between late January and late February on the solar calendar. Today Chinese people have adopted the Western calendar but continue to use the lunar calendar to mark important holidays. (Courtesy of the Library of Congress, Prints and Photographs Division.)

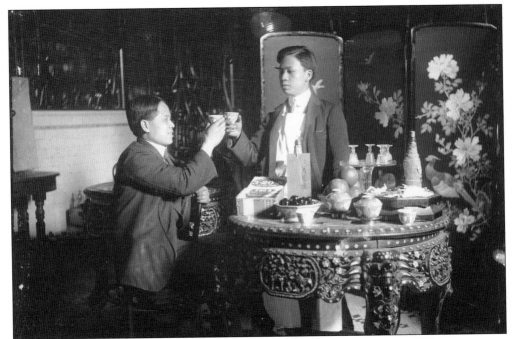

In 1912, two Chinese men share tea and offer one another Chinese New Year's greetings in Chinatown. Many Chinese people typically begin the New Year wearing new clothes to visit relatives and friends. Married couples give children *lai see* or *hong bao* (little red envelopes filled with new dollar bills for good luck money). (Courtesy of the Library of Congress, Prints and Photographs Division.)

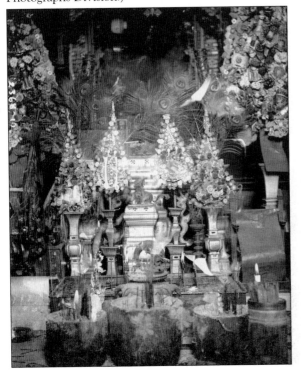

Many Chinese people visit temples to pray during Chinese New Year. This altar in Chinatown was decorated for Chinese New Year in 1912, the Year of the Rat. Each year corresponds to an animal of the Chinese zodiac. The rat, ox, tiger, rabbit, dragon, snake, horse, ram, monkey, rooster, dog, and pig rotate in order and repeat every 12 years. (Courtesy of the Library of Congress, Prints and Photographs Division.)

These storefronts on Mott Street are decorated with lanterns for Chinese New Year around 1911. Flowery Kingdom Restaurant and Tea Parlor at 14 Mott Street had a private dining room for ladies. A joss house was located next door at 16 Mott Street in the same building as King Hong Lau Company restaurant. (Courtesy of the Library of Congress, Prints and Photographs Division.)

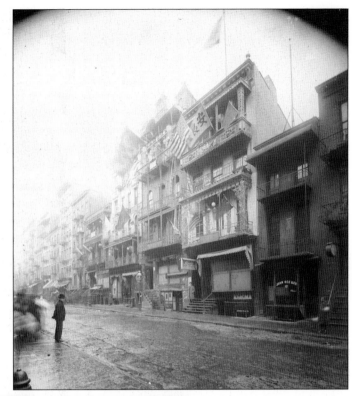

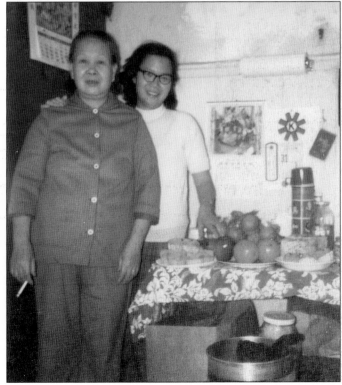

During Chinese New Year in the 1970s, Tsui So Mei (right) visited her mother Leung Yip Sheng (left) at her apartment in the Lower East Side. She came bearing oranges as a gift for her mother. Freshly made *fat gow* (prosperity cake) sat on the kitchen table. (Courtesy of Elizabeth Brown.)

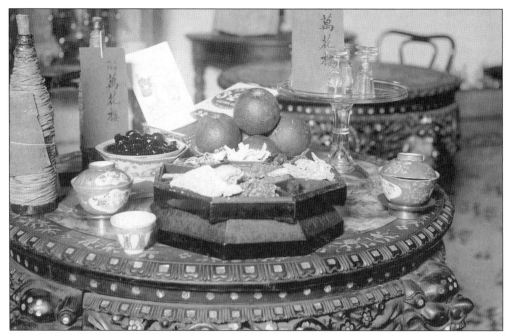

This feast in Chinatown was offered during the celebration of Chinese New Year in 1912. On the table were candies, fruit, and tea. Some Chinese Americans believe that what they eat during this time will have a bearing on their fortune for the upcoming year. (Courtesy of the Library of Congress, Prints and Photographs Division.)

A Chinese man receives a New Year's guest in Chinatown. During the two-week observance of Chinese New Year, family and friends say to each other *"gung hay fat choy"* (wishing you prosperity). Because bonding with family is especially important during this time of year, relatives visit each other throughout the celebration. (Courtesy of the Library of Congress, Prints and Photographs Division.)

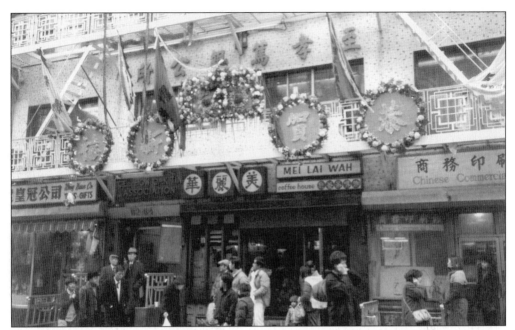

Chinese New Year festivities help preserve Chinese cultural heritage. Buildings in Chinatown are decorated during this time, including the Gee How Oak Tin Association, a family organization at 62 Bayard Street, and Mei Lai Wah Coffee House at 64 Bayard Street. Some pedestrians are seen covering their ears to protect themselves from the loud firecracker explosions. (Courtesy of Chei Lang Chian.)

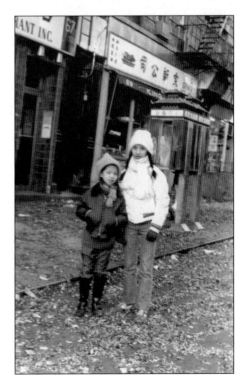

Tulien Aizawa (right) enjoys the Chinese New Year festivities with her sister. Traditionally this time of year is spent with family. The streets of Chinatown are covered with red paper firecracker wrappers, and the air is filled with smoke from exploding firecrackers. Firecrackers are wrapped with red paper because the color red symbolizes good luck. (Courtesy of Tulien Aizawa.)

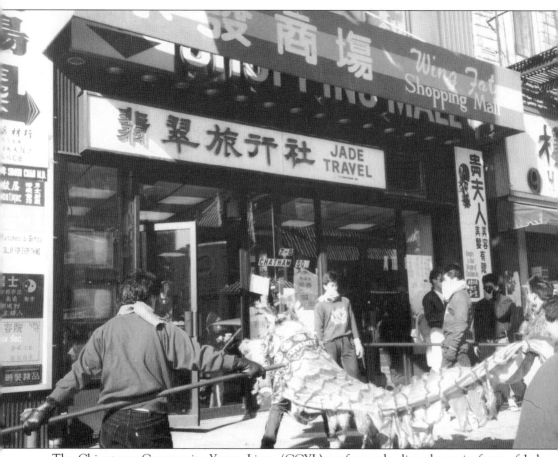

The Chinatown Community Young Lions (CCYL) performs the lion dance in front of Jade Travel. In a lion dance performance, one dancer controls the colorful lion's head adorned with tassels. This dancer also controls the lion's eyes and mouth. Another dancer controls the lion's sparkling body and tail. Some Chinese Americans believe that the lion dance will bring good luck and happiness for the upcoming year. Located at 8 Chatham Square, Jade Travel has a very desirable address. Many Chinese people believe that the number eight is a lucky number. The CCYL has been performing lion dances for more than 30 years. In addition to the Chinese New Year celebration in New York City, they also perform at special events throughout the tri-state area, including New Jersey, Connecticut, and Upstate New York. The organization enables Chinese children and young adults to reconnect with traditional Chinese culture. Donations help fund the programs, and volunteers help run the programs. (Courtesy of Chei Lang Chian.)

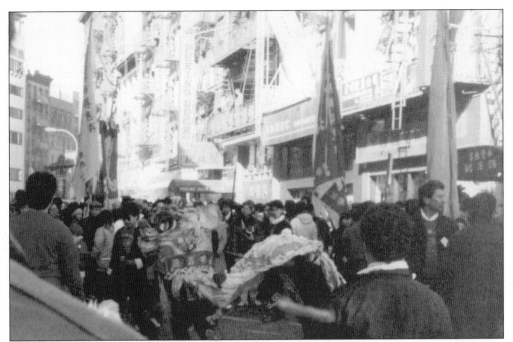

The Chinese lion dance dates back thousands of years. During Chinese New Year, lion dancers parade through Chinatown. Members of kung fu schools often perform the lion dances. This lion dance approaches the Peking Duck House on 28 Mott Street. Many Chinese people believe that the lion dance will scare away *gwai* (evil spirits) and clear the path for prosperity and good fortune. (Courtesy of Chei Lang Chian.)

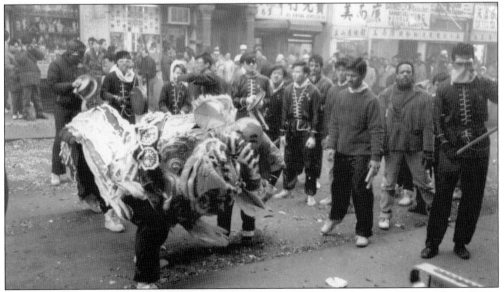

Percussion music accompanies the Chinese lion dance. Performers behind the lion play a drum, a gong, and two pairs of cymbals. The loud, lively music follows the movements of the lion. A laughing Buddha also performs in the lion dance, teasing the lion. The performer playing the Buddha, to the right of the lion, wears a mask and a robe and carries a fan. (Courtesy of Chei Lang Chian.)

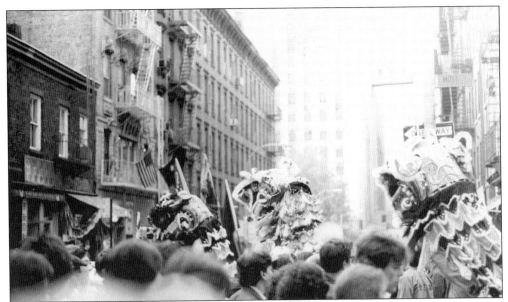

The Chinese lion dance parade route travels through the streets of Chinatown, including Mott Street. The lion dance goes up to the entrances of restaurants, banks, stores, apartment buildings, and offices. To sweep away the old and prepare for the new, the apartments shown in the background would be cleaned before New Year's Day. (Courtesy of Chei Lang Chian.)

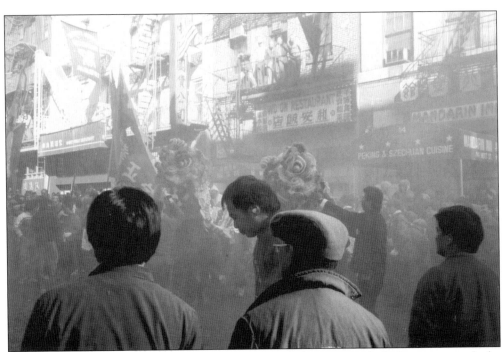

Because the streets of Chinatown are extremely crowded, some people find ways to watch the lion dance from afar, such as this fire escape above Wo On Restaurant at 16 Mott Street. One of the men keeping the crowds away from the performers wears earplugs to protect his ears from the exploding firecrackers and loud music. (Courtesy of Chei Lang Chian.)

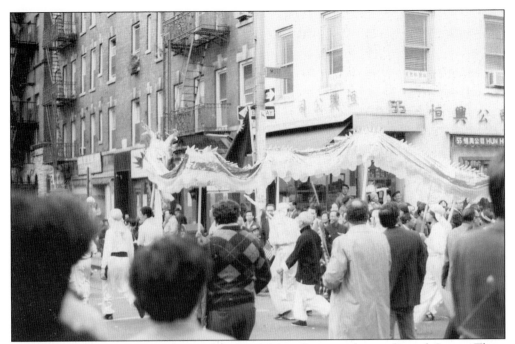

The Chinese New Year parade travels around Mott Street and onto Bayard Street. These performers use a different type of lion. This lion, controlled by many people with long sticks, is not elaborate and appears to be a less realistic lion. However, these performers still give an energetic show. (Courtesy of Chei Lang Chian.)

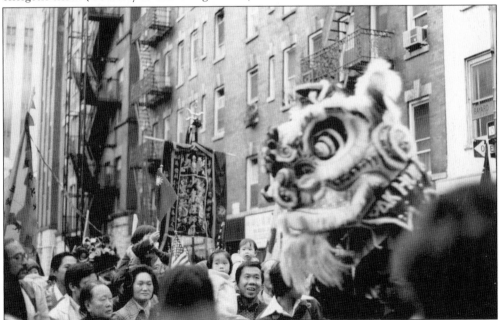

Taiwanese Americans in the crowd wave both the Taiwanese flag and the American flag while they watch the lion dance. The lion dons a long white beard for wisdom. The mirror on top of the lion's head helps scare away evil spirits. Many Chinese people believe that evil spirits would be frightened when they saw their own reflections. (Courtesy of Chei Lang Chian.)

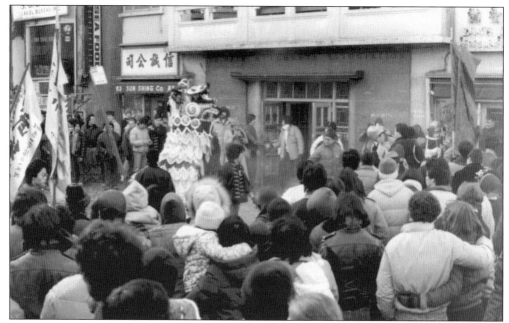

The lion dance procession stops in front of the Chinese Merchants Association at 83 Mott Street. When the lion first arrives, he is asleep. The loud music of the drum, the gong, and cymbals wakes up the lion. After the lion wakes up, he moves energetically with the beat of the music. (Courtesy of Tulien Aizawa.)

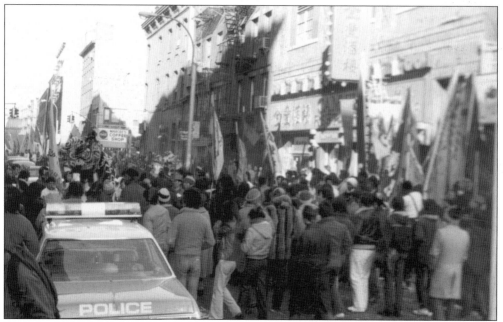

Thousands of Chinese Americans line the streets hours before the lion dance parade begins. The New York Police Department patrols the streets to control the crowds and to keep people safe during Chinese New Year celebrations. The personal use of firecrackers officially is prohibited by law. (Courtesy of Tulien Aizawa.)

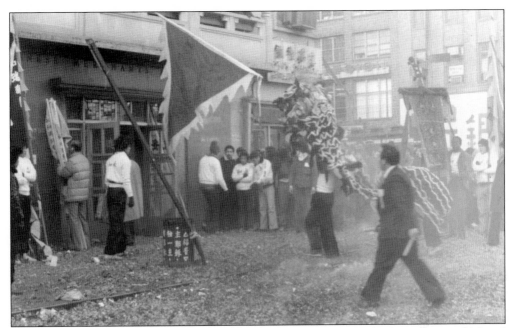

Each business or organization that the lion visits feeds the lion *choy* (a leafy green vegetable) and lai see. The lion puts the lai see in his pockets and spreads the vegetable leaves around to spread wealth. The lai see is a gratuity or donation. (Courtesy of Tulien Aizawa.)

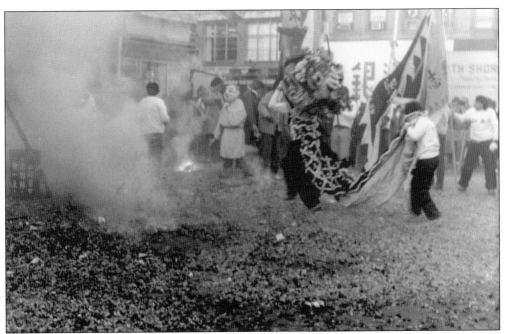

Police barricades keep the crowds away from the performers. The performer controlling the lion's tail covers his face to protect himself from the smoke of the firecrackers. The laughing Buddha plays with the lion during the performance. Behind him are several red telephone booths with tops decorated like the roofs of pagodas. (Courtesy of Tulien Aizawa.)

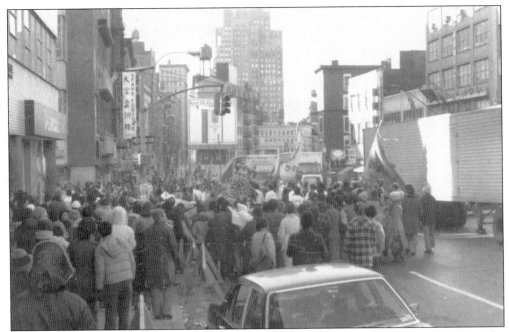

The lion dance procession is headed toward Grand Fortune Restaurant on Canal Street. The large number of trucks passing through Canal Street added to the congestion problem in Chinatown. Trucks often used Canal Street to reach New Jersey through the Holland Tunnel or Brooklyn via the Manhattan Bridge. (Courtesy of Tulien Aizawa.)

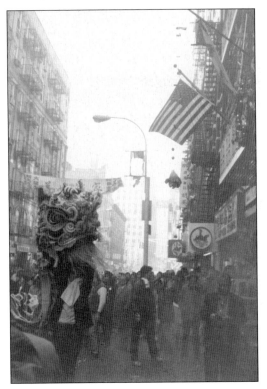

To feed the lion, a store on Mott Street hangs a head of lettuce and tangerines on a flagpole next to the American flag. Tangerines represent gold since the Chinese words for both tangerine and gold are pronounced "gum." After eating the lettuce and tangerines, the lion coughs them up to spread wealth and prosperity to all. (Courtesy of Chei Lang Chian.)

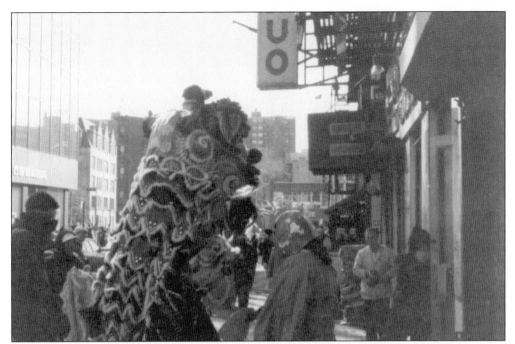

The lion and the laughing Buddha perform in front of Kam Kuo Food Corporation at 7 Mott Street. At Kam Kuo, Chinese Americans can buy hard-to-find items such as *dul see* (Chinese dried black beans), *doong qwoo* (dried Chinese mushroom), *gai lan* (Chinese broccoli), *dul gock* (long beans), and *foo qwa* (Chinese bitter melon). (Courtesy of Chei Lang Chian.)

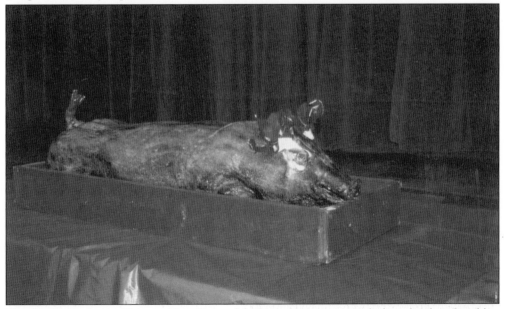

The food served at a Chinese New Year celebration dinner at a Catholic school in Brooklyn includes a whole roasted pig, the traditional main dish. This dish is sometimes served with plum sauce. The skin of *siu jew yok* (roasted pork) is crispy and full of flavor. Since red is the customary color during Chinese New Year, a red ribbon decorates the pig. (Courtesy of Chei Lang Chian.)

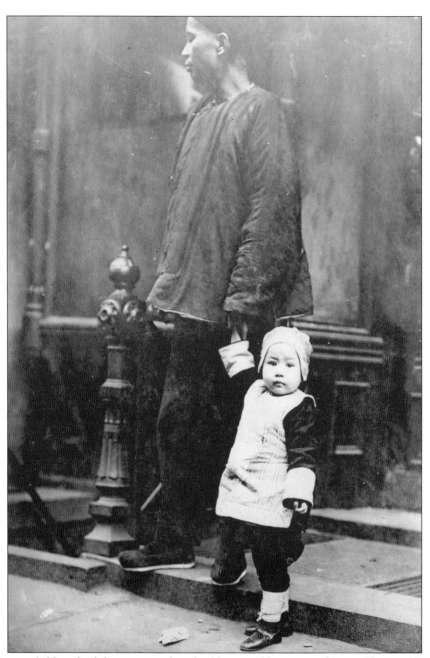

A Chinese child and adult step outside a building in Chinatown during Chinese New Year in 1909, the Year of the Rooster. During this time of year, many Chinese people take time off from work to go *bai nian* (make New Year's calls). They wear new clothes and visit friends and relatives. Today many Chinese people also make New Year's calls through the telephone, the internet, and text messaging. On New Year's Eve, immediate family members come together for a big dinner at home. Some traditional dishes include whole fish, scallops, roast pig, oysters, whole lobster, noodles, whole shrimps, and whole chicken. These foods are served with rice. The large quantity of food results in a surplus of leftovers for the New Year, which symbolizes wealth for the upcoming year. (Courtesy of the Library of Congress, Prints and Photographs Division.)

Three

CHINATOWN STREETS

The Manhattan Bridge links Brooklyn to Manhattan's Chinatown. However, Mott Street has been historically the gateway to the cultural center of Chinese Americans in the New York metropolitan area. Mott Street is still the home of a building with a wooden pagoda roof and also where the New York Chinese School is located. Some Chinese Americans who settled in the suburbs of New York City would come from up to 50 miles away during weekends to visit family, shop, eat, and attend special events. In addition, Chinatown is a popular year-round tourist destination.

Business establishments, such as restaurants, grocery stores, and other retail shops, serve Chinatown residents, as well as tourists. According to the Asian American Federation of New York, tour buses bring, on average, 2,000 visitors each day to Manhattan's Chinatown. Visitors enjoy coming to Chinatown for the shopping, the sightseeing, and the food.

Restaurants serve traditional Chinese dishes along with Americanized items, such as chop suey, chow mein, and egg foo young. Stores sell jewelry, produce, seafood, Chinese traditional medicine, martial arts supplies, gifts, clothes, and antiques. Other important sites in the community include the Kim Lau Memorial Arch, a memorial for the Chinese Americans who died during World War II, and the Museum of Chinese in the Americas, a museum with exhibitions about Chinese history in the United States.

The development of New York City's Chinese community that had started on a few narrow winding streets soon spread to nearby areas. As the population grew, the community borders overflowed into the city hall area, Little Italy, and the East Village and new Chinatowns formed in Queens and Brooklyn. According to the United States Census Bureau's 2003 data, Manhattan has a population of 90,727 Chinese Americans (making up 6 percent of Manhattan's total population), Brooklyn has a population of 117,152 Chinese Americans (making up 4.8 percent of Brooklyn's total population), and Queens has a population of 163,763 Chinese Americans (making up 7.4 percent of Queens' total population). These figures do not include people who reported more than just Chinese as their race and do not include Taiwanese Chinese Americans.

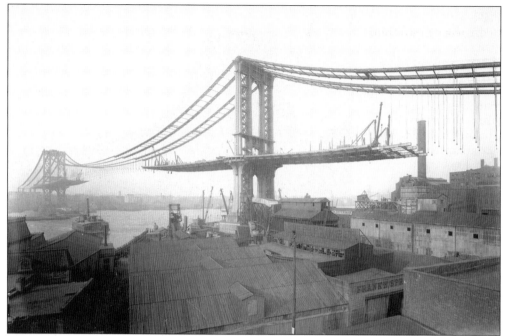

The Manhattan Bridge, built in 1909, connects the Bowery and Canal Street in Chinatown with Flatbush Avenue in downtown Brooklyn. This bridge, designed by Leon Moisseiff, has six roadways and two subway tracks for travel between lower Manhattan and downtown Brooklyn. (Courtesy of the Library of Congress, Prints and Photographs Division.)

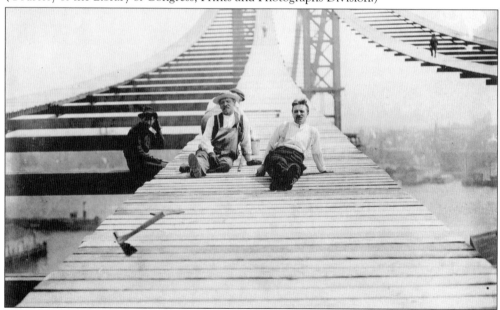

Builders used temporary footpaths atop the Manhattan Bridge during its construction. Workers, shown here, take a midday break. It took eight years to complete the bridge. Finished in 1909, the Manhattan Bridge crosses the East River, connecting Chinatown with Brooklyn. The main span of the bridge is 1,470 feet, and the total length is 6,855 feet. (Courtesy of the Library of Congress, Prints and Photographs Division.)

Building the Manhattan Bridge required attaching drop cables. The B, D, N, and Q subway trains run on tracks on this suspension bridge. These train lines conveniently take people to two Chinatowns in Brooklyn. According to the New York City Department of Transportation, an average of 78,000 vehicles and 350,000 people cross the bridge each day. (Courtesy of the Library of Congress, Prints and Photographs Division.)

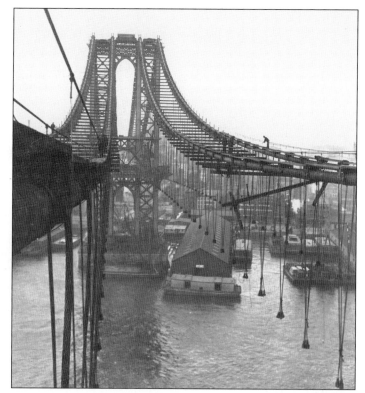

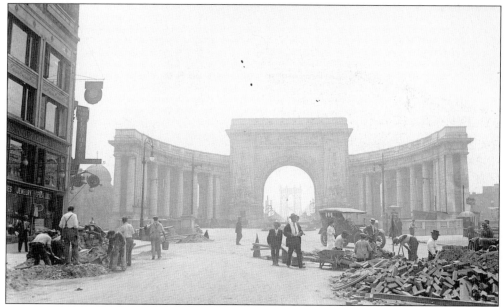

Manhattan Bridge Plaza sits on Chatham Square. Many of Chinatown's streets run into Chatham Square, including the Bowery, Mott Street, Park Row, Division Street, Doyers Street, Worth Street, and East Broadway. Before the Manhattan Bridge was built in 1909, this area was very sparse and peaceful. By the 1960s, the area became much more densely populated. (Courtesy of the Library of Congress, Prints and Photographs Division.)

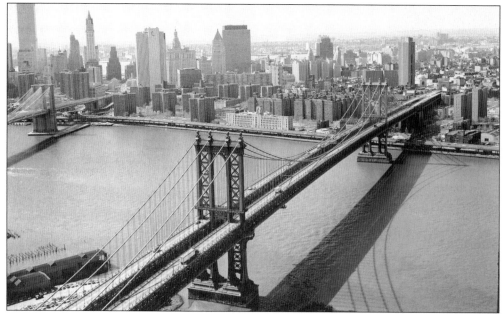

This view of the Manhattan Bridge looks toward Manhattan with the Brooklyn Bridge on the left. On the Manhattan side of the East River, to the left of Chatham Square, is Confucius Plaza, where a tall housing complex stands with a statue of Confucius. The World Trade Center stands in the background behind the Brooklyn Bridge. (Courtesy of the Library of Congress, Prints and Photographs Division, Historic American Buildings Survey.)

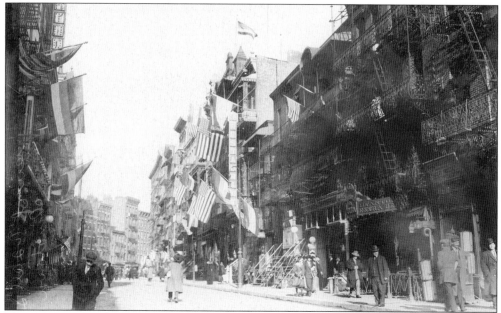

This street scene shows life in Chinatown on January 1, 1913. In addition to pedestrians, Chinatown streets today are more frenetic, congested with traffic, and full of car exhaust fumes. Shops display rows of roast ducks, roast pork, and poached chickens in the windows, and telephone booths have pagoda-like designs. (Courtesy of the Library of Congress, Prints and Photographs Division.)

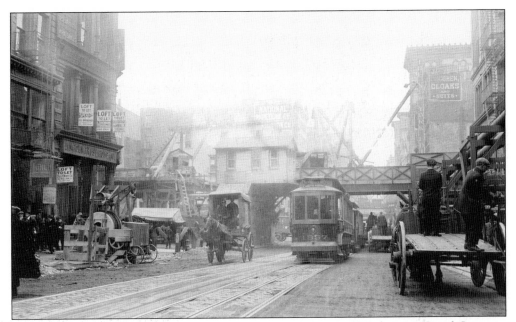

Horse-drawn carriages and trolleys provided transportation on Broadway at Canal Street in Chinatown around 1911. Today the Canal Street subway station at this intersection is where the J, M, Z, N, Q, R, W, and six subway lines pick up and drop off passengers. Cobblestones remain on parts of the road. (Courtesy of the Library of Congress, Prints and Photographs Division.)

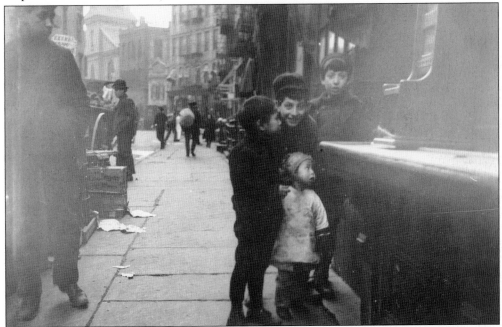

Four children stand in front of a shoeshine stand on a littered street in Chinatown in 1903. The Chinese child is dressed in traditional Chinese silk clothing, while the other children are dressed in Western styles of clothing. Shoeshine stands have since been replaced with fruit and vegetable stands. However, streets remain littered. (Courtesy of the Library of Congress, Prints and Photographs Division.)

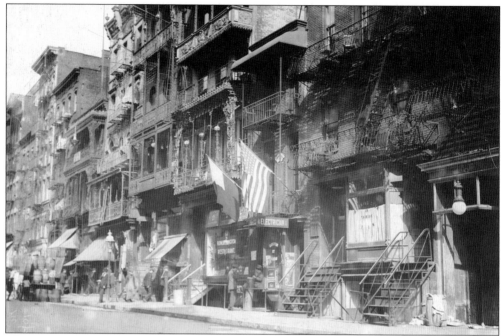

The Chinese flag and the American flag hang from the Chinese revolutionary headquarters in New York City around 1910. Overseas Chinese people supported Dr. Sun Yat-sen, leader of the revolutionary movement. This movement sought to establish a new democratic government in China. Public School 131 on Hester Street in Chinatown is named Dr. Sun Yat-sen Middle School. (Courtesy of the Library of Congress, Prints and Photographs Division.)

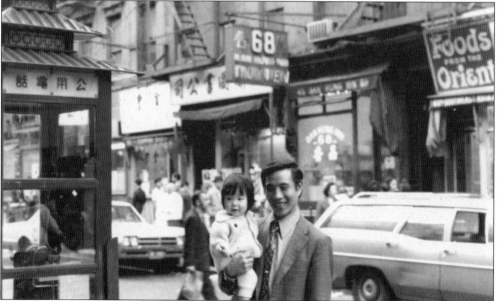

Josephine Lee (left) and her godfather spend the afternoon in Chinatown after having brunch around 1970. On a typical weekend day, many Chinese American families wait in long lines at crowded restaurants to *yum cha* (drink tea). Restaurants usually cannot accommodate the weekend crowds without having different dining parties share tables. (Author's collection.)

54

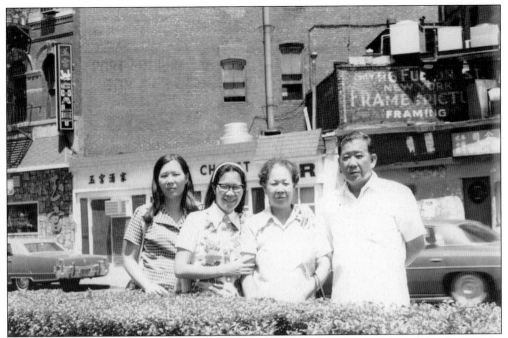

From left to right, Su Ping Chui, Tsui So Mei, Leung Yip Sheng, and Tsui Chenk meet for brunch near Columbus Park in Chinatown in the early 1970s. A billboard advertising a framing business on Fulton Street sits above a Chinese chalet and bar. English and Chinese signs are found throughout Chinatown. (Courtesy of Elizabeth Brown.)

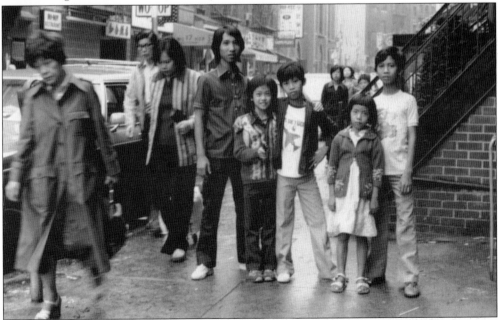

Some young Chinese Americans spent time with their friends after school and on weekends in Chinatown. They often played video arcade games at Chinatown Fair on Mott Street and Chatham Square. The dancing chicken that played tic-tac-toe at Chinatown Fair had attracted many tourists over the years. (Courtesy of Tulien Aizawa.)

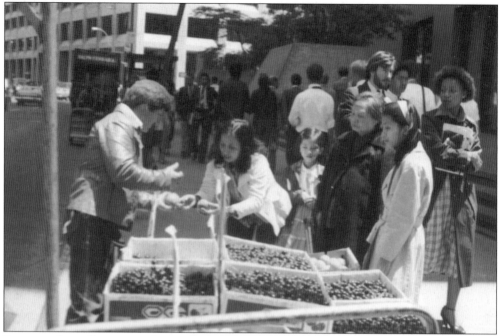

Street vendors sell a variety of items throughout Chinatown. Some stalls offer an exotic selection of fruits and vegetables. Tulien Aizawa (far right) shops with her family for some Asian pears. Her mother is determined to *gan langde* (choose beautiful ones). Other stalls sell replicas of luxury brand-name watches and handbags, while food carts sell Hong Kong cakes and noodles. (Courtesy of Tulien Aizawa.)

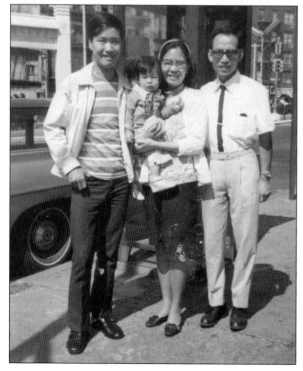

Tsui So Mei (center right) visits the Kim Lau Memorial Arch, pictured here in the background on the left, around 1970. The American Legion built the memorial at Chatham Square in memory of Chinese Americans who died in defense of freedom and democracy during World War II. (Author's collection.)

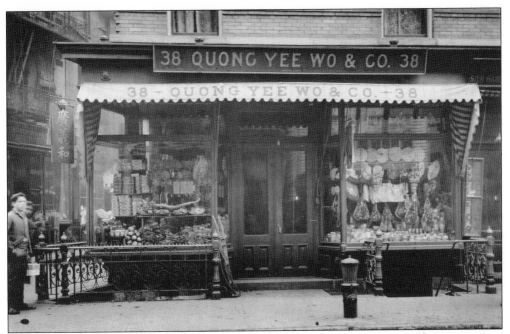

Quong Yee Wo and Company displayed vegetables, dried meats, and packaged goods in its windows in 1903. According the Asian Federation of New York, more than 1,400 retail stores are located in Manhattan's Chinatown today. Store owners today also display their goods on the sidewalks in front of their stores. (Courtesy of the Library of Congress, Prints and Photographs Division.)

Fish markets in Chinatown sell fresh whole fish and other live seafood. Pictured here, a fish market displays its catch on ice on the sidewalk. Typically prices written on cardboard signs are lowered at the end of the day to sell the remaining inventory. Some Chinese Americans shop around at different vendors to find the one with the day's freshest food items. (Author's collection.)

The streets of Chinatown are filled with delicatessen counters that sell cooked food for customers to carry out. Some Chinese Americans purchase prepared food by the pound to eat at home or at work. For convenience, they can buy cooked meats such as duck, pork, chicken, and tripe. (Author's collection.)

Bakeries, found on many streets in Chinatown, sell an assortment of Chinese baked goods, including almond cookies, *dan tat* (egg custard tart with a flaky pastry crust), and various types of *bao* (buns with savory or sweet fillings). Elizabeth Brown (left) and Josephine Lee (right) enjoy eating their bao at a park in Chinatown in the early 1970s. (Courtesy of Elizabeth Brown.)

Four

WORK LIFE

During the economic depression of the late 1800s, some white American laborers believed that Chinese immigrants worked too cheaply and took away their jobs. Cartoons negatively depicted Chinese Americans with pigtails and slanted eyes living in crowded quarters among rats. The media helped persuade people to conclude that "The Chinese Must Go."

Many early Chinese immigrants worked within the Chinese community because they spoke little English. They worked hard to make a living and to provide for their families. They invested in Chinese restaurants, Chinese grocery stores, and garment factories. These small businesses also depended on the help of family members. Initially Chinese restaurants served the Chinese community, but owners quickly recognized that they could profit from offering mock Chinese dishes that pleased non-Chinese patrons. Similarly Chinese stores that initially sold Chinese herbs to the Chinese community later also catered to non-Chinese customers.

During World War II, Japan's attack on Pearl Harbor led to significant changes for the work life of some Chinese Americans in the United States. The armed forces drafted many Chinese Americans in New York City. Under the wartime shortage of labor, the United States government outlawed racial discrimination in defense-related jobs and the Chinese gained experience working in aircraft factories, laboratories, offices, and shipyards.

According to the Asian American Federation of New York, nearly 4,000 Chinese-owned-and-operated businesses exist in Manhattan's Chinatown today. As the newer generations pursue college degrees, many Chinese Americans also are entering professional jobs and becoming skilled specialists such as doctors, teachers, writers, musicians, accountants, architects, business managers, engineers, and research scientists.

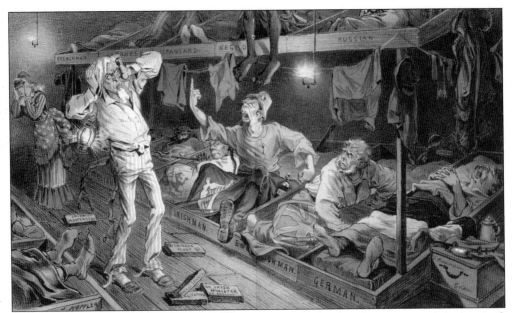

Joseph Ferdinand Keppler's illustration of Uncle Sam's diverse lodging house, published in *Puck* magazine in 1882, showed an Irishman confronting Uncle Sam in a boardinghouse. Laborers were trying to sleep. The Irishman kicked up a row, throwing bricks labeled "The Chinese Must Go," while the Frenchman, the Japanese, the Russian, the Italian, and the German slept peacefully. (Courtesy of the Library of Congress, Prints and Photographs Division.)

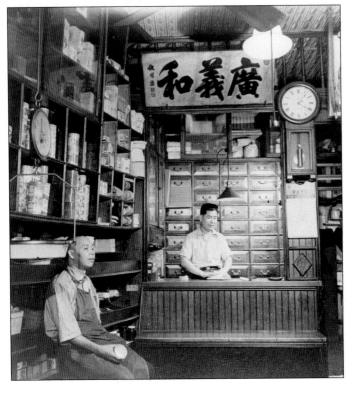

Two merchants work in a typical Chinese grocery store in Chinatown in 1942. Store clerks frequently worked long hours. Stores often sold Chinese herbs. Many Chinese people believe that herbal soups have medicinal qualities. *Say may tong* (four flavors soup) helps restore harmony and balance in the body. (Courtesy of the Library of Congress, Prints and Photographs Division, Farm Security Administration/ Office of War Information Collection.)

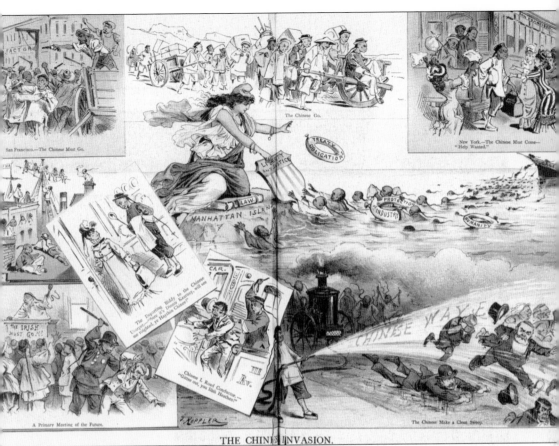

THE CHINESE INVASION.

Magazines and newspapers widely publicized "The Chinese Invasion" in the late 1800s. Keppler's composite of nine cartoons captured the prevailing negative sentiments about Chinese immigrants taking over the United States, especially in San Francisco and New York. These drawings appeared in *Puck* magazine in 1880, illustrating that "The Chinese Must Go" and "The Chinese Make a Clean Sweep." During this time, some white Americans held much hostility and animosity toward Chinese immigrants. Due to high unemployment, some white American laborers believed that the Chinese immigrants competing for jobs were willing to work longer hours and for less money than other workers. They believed that Chinese immigrants were taking away their jobs. The widespread opinion that "The Chinese Must Go" resulted in the Chinese Exclusion Act, a law banning the immigration of Chinese laborers. (Courtesy of the Library of Congress, Prints and Photographs Division.)

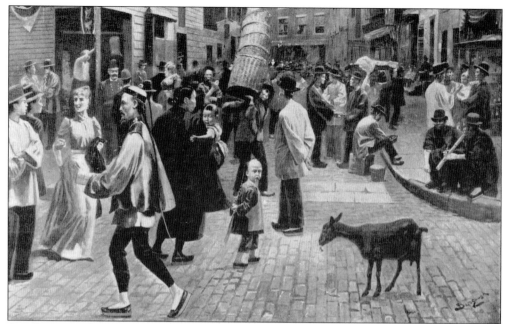

An illustration by William Bengough published in *Harper's Weekly* in 1896 shows the foreign element in New York City: the Chinese colony on Mott Street. Chinese men often wore their hair long and tied back. Mott Street is still the core of Chinatown and attracts a large number of tourists. (Courtesy of the Library of Congress, Prints and Photographs Division.)

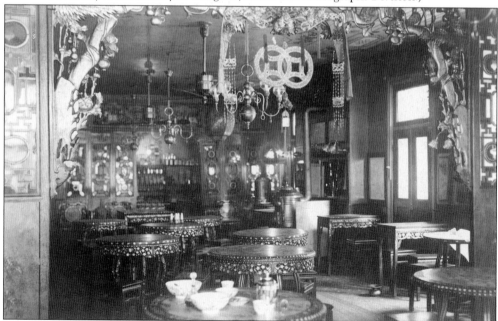

This photograph shows the interior of a typical tearoom in Chinatown in 1903. For centuries many Chinese people have believed in the health benefits of tea. More recently, researchers at Brigham and Women's Hospital found that drinking certain types of tea may help strengthen the body's immune system response when fighting off infection. (Courtesy of the Library of Congress, Prints and Photographs Division.)

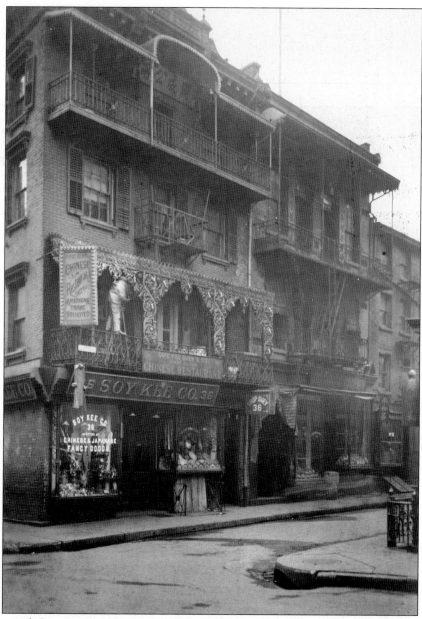

Soy Kee and Company, a Chinese general store pictured here in 1903, sold fancy imported Chinese and Japanese goods in Chinatown. Windows displayed merchandise in order to draw customers into the store. The store sold goods such as packaged foods, fresh vegetables, handheld fans, porcelain plates, teacups, and dried meats. Many Chinese recipes incorporate dried meats such as *lop yok* (Chinese bacon) and *lop chong* (Chinese sausage). Above the store, Guie Yee Quen and Company First Class Chinese Restaurant solicited American trade with chop suey on its menu. Restaurants also tailored chow mein to the palate of American customers. Today more than 200 restaurants serve different types of cuisine, including Cantonese, Shanghainese, Szechuan, Singaporean, Japanese, Indonesian, and Asian fusion. These authentic restaurants attract customers with traditional dishes from different regions in China and the rest of Asia. (Courtesy of the Library of Congress, Prints and Photographs Division.)

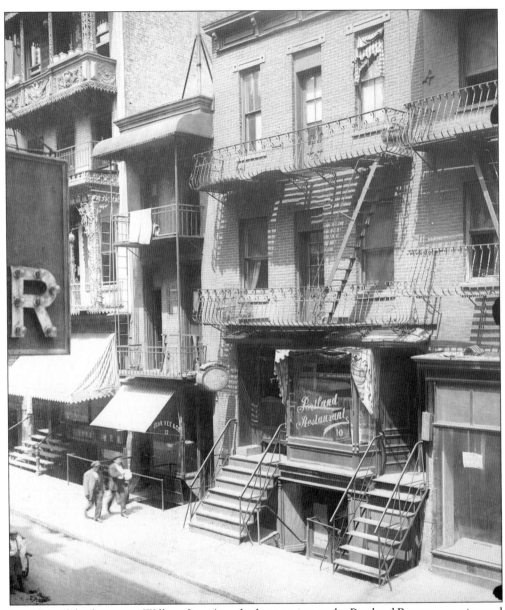

Leon Ling (also known as William Leon) worked as a waiter at the Portland Restaurant, pictured here on the first floor. This restaurant served Chinese American chop suey. Leon was Elsie Sigel's alleged slayer. They met at this mission on Eighth Avenue. Sigel was a young white woman. Her body was found in a trunk in Leon's apartment on the second floor in 1909. Love letters found in the apartment showed that the two people were involved in an interracial romance. The police searched for Leon, the primary suspect, throughout the United States and Canada. The police scrutinized Chinese neighborhoods in numerous cities and interrogated countless Chinese men. In Vancouver, the police probed all Chinese men arriving by train from the East. Despite the wide search, the police never caught Leon. (Courtesy of the Library of Congress, Prints and Photographs Division.)

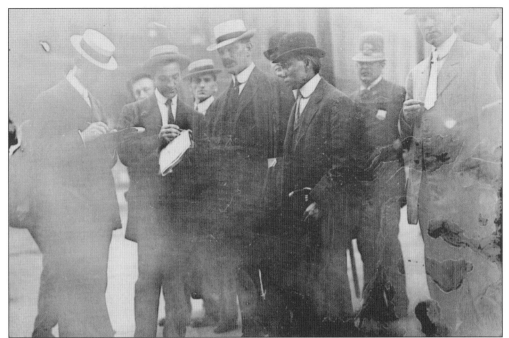

Chang Sing (also known as Chong Sing), a Chinese man, was implicated as a witness in the murder of Sigel. He met with police and reporters upon arrival in New York City on June 22, 1909. Sigel, the granddaughter of Gen. Franz Sigel, was a missionary in Chinatown and visited many Chinese restaurants during her mission work. (Courtesy of the Library of Congress, Prints and Photographs Division.)

Peter Chian's parents owned a Chinese laundry business. In order to work the long hours required to run a small business, they would bring Chian to work with them. Pictured here crawling, Chian often would play on top of the brown paper used to wrap the customers' clean laundry. (Courtesy of Peter Chian.)

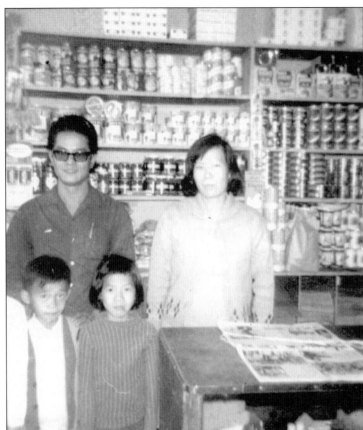

From left to right, (first row) Benito León and Sonia Kuenzig; (second row) Ricardo León and Su Ping Chui posed for a photograph in their grocery store in Mexicali, Mexico. Like many Chinese families, the León family saved as much money as possible in order to start their own business. As small business owners, they worked long hours and their children often helped. (Courtesy of Benito León.)

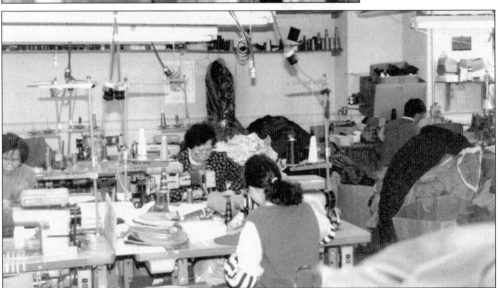

After Su Ping Chui (center) and her husband Ricardo León immigrated to New York City from Mexico, they started a garment factory in Chinatown. Their children often helped out at the factory. Chui's mother and two sisters also worked there. After the Leóns retired, their children moved away from New York City and they closed the factory. (Courtesy of Benito León.)

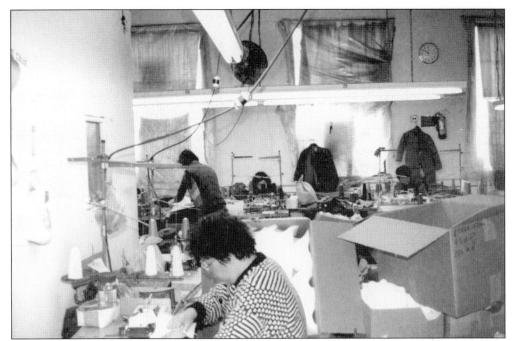

Each worker quickly worked through boxes of fabric. Sometimes they wore masks over their faces to shield themselves from lint. They hung their coats and lunches in plastic bags near their machines. Chinese radio programming often blasted in the background. Garment factories typically became hot from the machinery being used. Therefore large fans were used to cool the work areas. (Courtesy of Benito León.)

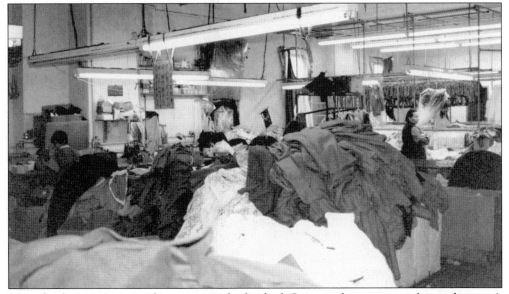

Mounds of garments sat in a bin waiting to be finished. Garment factories manufactured women's sportswear sold in department stores, including career and casual clothing. Work at garment factories could be found through advertisements in Chinese newspapers. The International Ladies' Garment Workers' Union (ILGWU) offered garment workers health insurance. Most garment workers trained on the job and earned piece rates. (Courtesy of Benito León.)

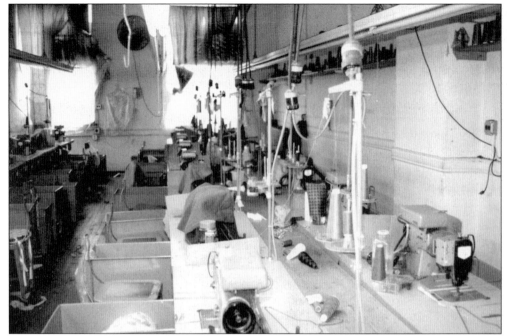

Apparel manufacturers provided design specifications and determined production volume. Garment factories then produced the clothing. Merrow operators ran the machines pictured here to sew butt seams on garment pieces. Button and button hole sewing machine operators, usually men, stitched button holes and fastened buttons onto garments. Thread cutters, usually older women, trimmed threads from finished pieces of clothing. (Courtesy of Benito León.)

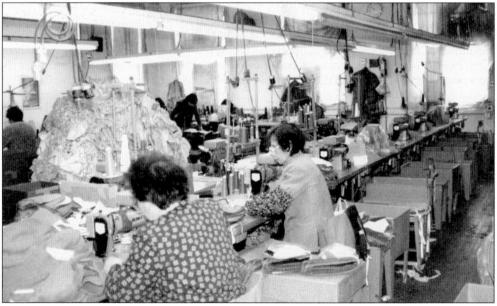

Working in clothing production can be difficult. Workers sit leaning over tables and operate machinery. Most workers were Chinese American women who spoke little or no English. Many prefer to work for Chinese employers and with Chinese coworkers. As a result, they would not need to learn English. (Courtesy of Benito León.)

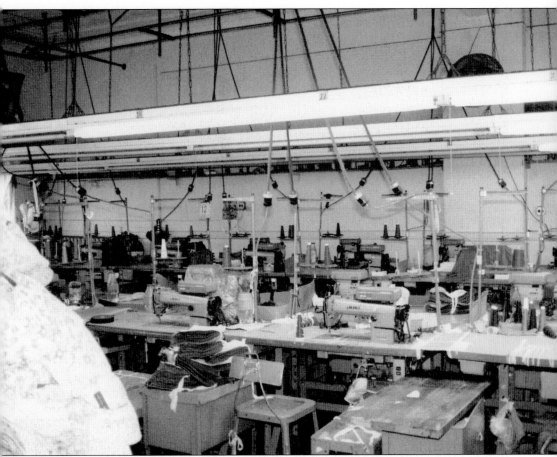

Seamstresses attached collars, cuffs, zippers, and pockets with the sewing machines pictured here. Workers preferred easy garments over complicated ones. They could complete many more of the easy pieces per hour and found this work well-paid, calling it *see yul gai* (soy sauce chicken). They complained about more complicated work, calling it *jew qwat* (pig's bones). The analogy is that soy sauce chicken is easier to eat than pig's bones. According to the Asian American Federation of New York, 246 garment factories in Chinatown today employ nearly 14,000 garment workers. The apparel manufacturing sector represents the largest industry in Chinatown. As a result of the World Trade Center tragedy of September 11, Chinatown's economy experienced significant negative effects. Garment factories suffered revenue losses, and more than 40 garment factories shut down. Chinatown's garment industry lost $490 million the year following September 11. (Courtesy of Benito León.)

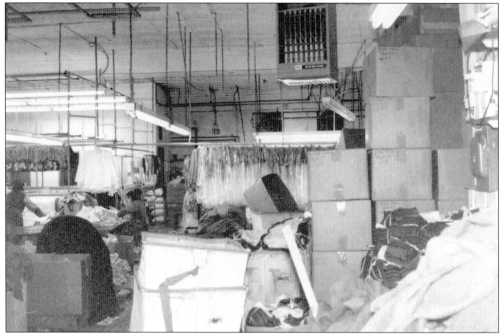

Layout workers and markers determined the best arrangement of the pattern pieces in order to minimize wasting fabric. Hand cutters cut out various pieces of material following the outline of patterns and bundled them. The bundles pictured here sat in boxes while waiting to be sewn. (Courtesy of Benito León.)

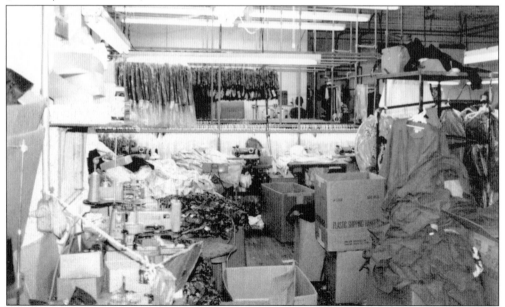

Steam pressers, usually men, pressed garments on padded ironing boards to ensure that the garments were wrinkle-free. Since steam pressers work standing on their feet, their work can be difficult. Finishers organize the clothing by type and size and put them on racks with hangers, like the ones pictured here. They then trim off any excess threads before putting them in plastic bags. (Courtesy of Benito León.)

Tulien Aizawa's mother owned a music store in Vietnam selling both Chinese and Vietnamese records and tapes. Many Chinese people owned small businesses, because self-employment meant independence. After saving enough money, Aizawa's family fled from the Communist regime and immigrated to New York City to find better opportunities for their future. (Courtesy of Tulien Aizawa.)

After Aizawa's family immigrated to New York City from Vietnam, they opened another family business. They owned a professional color photography lab in Manhattan. Pictured here with his camera around his neck, Aizawa's father was taking photographs in Brooklyn. After he retired, his sons managed the family business. (Courtesy of Tulien Aizawa.)

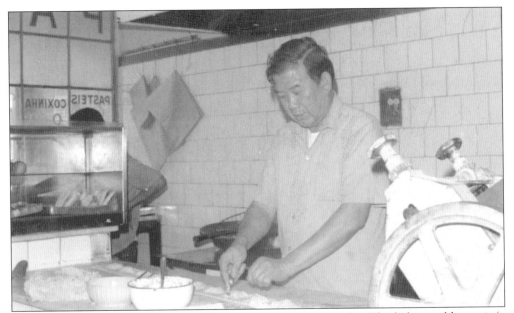

Tsui Chenk worked in a bakery in Brazil making Brazilian snacks. The bakery sold *pasteis* (a pastry filled with chicken and ham) and *coxinha* (deep-fried dough with spicy chicken). He continued working in the food industry at a restaurant when he immigrated to New York City in the 1970s. (Courtesy of Chei Lang Chian.)

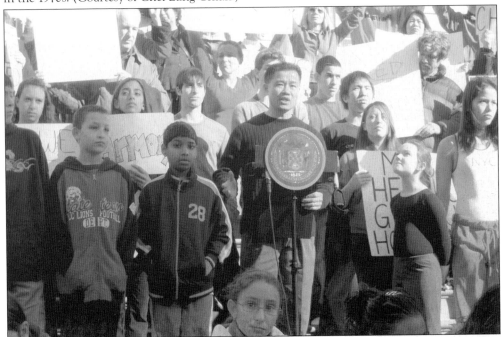

John Liu (center), New York City council member for District No. 20, speaks to the community. As a member of the council's committee on education, he focuses on the need to raise standards in public schools and to increase confidence and faith in teachers to educate kids. He is the first Asian Pacific American to be elected in New York City. (Courtesy of Sharon Lee, Office of Council Member John Liu.)

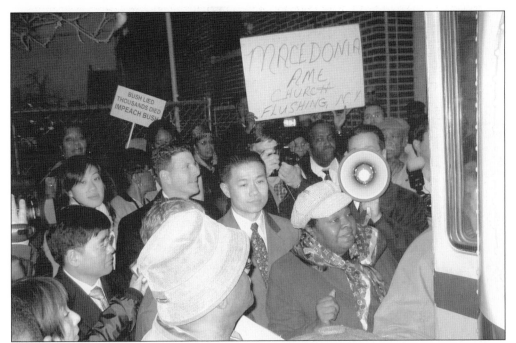

The New York City Council adopted a resolution declaring December 1 as Rosa Parks Commemoration Day in New York City. Council member John Liu (center) participated in an event remembering Parks with members of the community boarding a bus from the past. (Courtesy of Sharon Lee, Office of Council Member John Liu.)

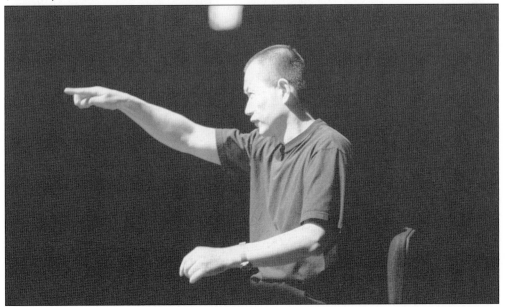

Tan Dun conducted an orchestra during a rehearsal of his *Water Passion after St. Matthew*. He wrote the composition to commemorate the 250th anniversary of the death of Johann Sebastian Bach for Internationale Bachakadamie in Stuttgart. The work has been performed around the world, including Germany, Japan, Great Britain, Russia, United States, South Korea, and China. (Courtesy of Hugh Barton, Tan Dun, Jane Huang and Parnassus Productions.)

Seamen of Chinese nationality were detained on board when their ships touched American ports in the past. In 1942, the United States Navy granted Chinese seamen shore leave for the first time in wartime America. Chinese seamen on United Nations' vessels were now allowed to obtain shore leave in American ports, such as this one in New York City. Some Chinese American women also joined the military during World War II. The Women's Army Corps recruited many Chinese American women to work in various jobs. Some of these women worked as translators and helped the United States Army interrelate with the Chinese allies. Others worked in aerial photograph interpretation, air traffic control, and weather forecasting. Some Chinese American women also joined the United States Public Health Service Cadet Nurse Corps during World War II. (Courtesy of the Library of Congress, Prints and Photographs Division, Farm Security Association/Office of War Information Collection.)

Five

CULTURE AND TRADITIONS

Many Chinese immigrants brought traditional cultural ways of life with them to New York City. They stressed the importance of family, education, and perseverance. They celebrated significant Chinese holidays such as Chinese New Year, a newborn's one month birthday, the Harvest Moon Festival, and Ching Ming. They burned incense to honor their ancestors and returned to their homeland to maintain links with their heritage.

Some Chinese American parents raised their children eating Chinese food and going to Chinese school. They exposed their children to Chinese music. Some Chinese American parents even expected their children to marry the individuals selected by their parents. They did not want to give up their Chinese ways of life.

Nonetheless, many Chinese Americans found it challenging to hold onto their deep-rooted values. Cultures and traditions from their Chinese backgrounds began to change in an American setting. Some Chinese American children, exposed to American culture, were not always willing to speak Chinese and did not want to be restricted by old Chinese customs.

Inevitably, new ways of life formed for many Chinese Americans in New York City. Marriages between Chinese Americans and non–Chinese Americans created modern multicultural families. Educated in American schools, the newer generations were exposed to American customs and American mass media. Some Chinese American families began taking on traditions from American society, including holidays such as Christmas and Thanksgiving.

Today most Chinese American children form their own ideas about education, marriage, careers, and recreation. The characterization of the Chinese American family in New York City will continue to change with assimilation and the passage of time.

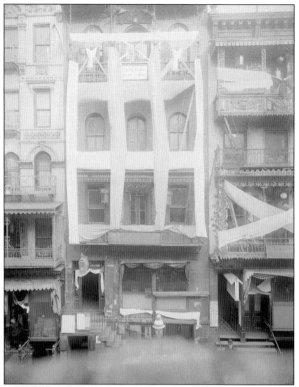

Joss houses were places of worship for some Chinese Americans. This Chinese redbrick joss house on Mott Street in Chinatown, with a white cloth hung across the doorway, was in mourning. Many Chinese people believed that the color red had protective traits that would fend off evil. (Courtesy of the Library of Congress, Prints and Photographs Division.)

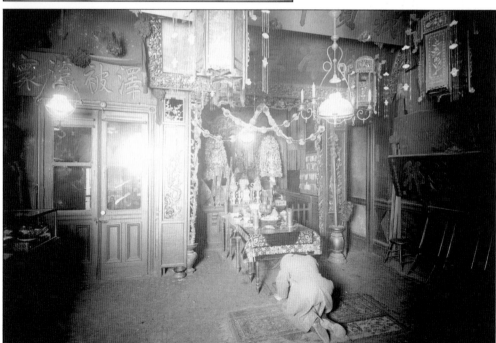

A worshipper prays in a joss house in Chinatown in 1911. Interiors of joss houses were elaborately decorated and dimly lit. Sticks of incense, called joss sticks, burned and food rested at the altar as an offering to the spirits. (Courtesy of the Library of Congress, Prints and Photographs Division.)

Many Chinese people celebrate a baby's birth one month after he or she is born. The traditional *mun yueh* (full month) celebration welcomes the baby into this world after the mother has recovered from the baby's birth. Typically the new parents host a big banquet at a Chinese restaurant. Close relatives often give the baby gold jewelry. Family and friends give the newborn *hong bao* (bright red envelopes with money inside). In addition to a baby's birth, hong bao are traditionally given during weddings, birthdays, and Chinese New Year. They are available in different designs, including the Chinese zodiac and the Chinese fishing boat. Sometimes Chinese characters, including one that means good luck, are imprinted in the color gold on the red envelopes. The envelopes contain the color gold because gold is cherished in the Chinese culture. (Author's collection.)

In early April, during Ching Ming (Tomb Sweeping Day), some Chinese Americans prepare special food offerings to commemorate their ancestors. This ritual performed at a home altar in New York City would be similar to the ritual performed at a cemetery in China. This custom, dedicated to the memories of ancestors, serves as a reminder of the significance of family relationships and the wisdom of elders. (Courtesy of Tulien Aizawa.)

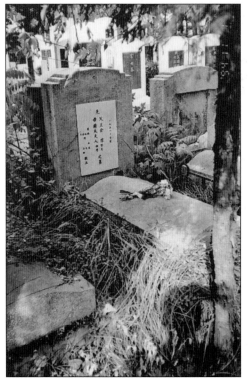

Chu-Ching Hu's grandparents' graves are in China. During Ching Ming, many Chinese people tidy up the areas around their ancestors' graves, clean their ancestors' headstones, and put out fresh flowers where their ancestors were buried. Food is also laid out as an offering for the spirits. (Courtesy of Chu-Ching Hu.)

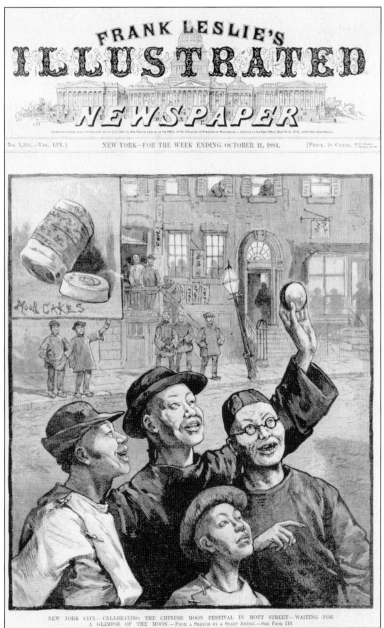

FRANK LESLIE'S ILLUSTRATED NEWSPAPER

No. 1,516.—Vol. LIX.] NEW YORK—FOR THE WEEK ENDING OCTOBER 11, 1884. [PRICE, 10 CENTS,

NEW YORK CITY.—CELEBRATING THE CHINESE MOON FESTIVAL IN MOTT STREET—WAITING FOR A GLIMPSE OF THE MOON.—FROM A SKETCH BY A STAFF ARTIST.—SEE PAGE 119.

This sketch, illustrated in 1884 in *Frank Leslie's Illustrated Newspaper*, shows men on Mott Street looking up into the sky during the celebration of the Chinese Moon Festival, also known as the Mid-Autumn Festival or the Harvest Moon Festival. This holiday occurs on the 15th day of the eighth month of the lunar calendar, which falls in autumn and corresponds to a date between early September and early October on the solar calendar. The men pictured here wait to catch a glimpse of the moon, which is particularly clear and bright during this time of year. Traditionally people exchange boxes of *yueh bang* (moon cakes) during the celebration. Moon cakes are pastries filled with sweetened bean paste and preserved egg yolks. Bakeries also sell special cookies in the shapes of Buddhas, fish, and pigs. (Courtesy of the Library of Congress, Prints and Photographs Division.)

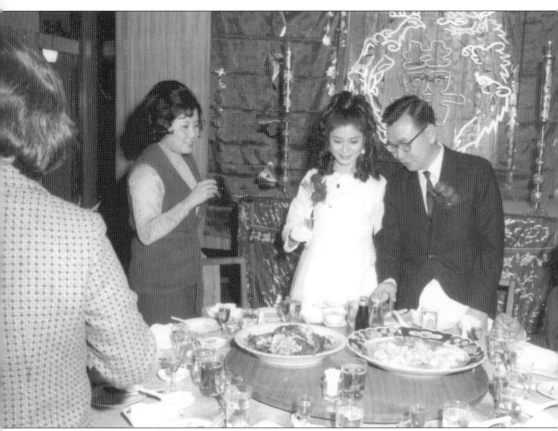

Edison Chu's parents, Yu Man Chu (left) and Szu Hsiung Chu (right), raise their glasses for a toast with their guests at their wedding banquet in Taiwan in the 1960s. The character for double happiness and a phoenix hang on a wall behind them. Traditionally the size of the wedding is a way to show the wealth of the groom's parents. Invitations to the wedding banquet would be sent to family and friends, but also to neighbors, acquaintances, and business associates. Serving *yu chee tong* (shark's fin soup) at a wedding banquet represents wealth and honors the guests. Shark's fin, a very expensive Chinese delicacy that is difficult to prepare, is served on special occasions. It is valued for its therapeutic qualities. Some Chinese people follow an age-old custom that calls for the groom's family to bestow gifts of money and goods on the bride's family. Today many Chinese Americans no longer follow these customs. (Courtesy of Edison Chu.)

Multicultural marriages reflect the
multiethnic character of the people living
in New York City. Josephine Lee (far left)
married Joseph Moore Jr. (far right) at a
Catholic church in Brooklyn. Moore's
family is Irish, German, Scottish, and
Russian. During their wedding ceremony,
the bride and groom lit a unity candle,
representing the union of their two families
into one. (Author's collection.)

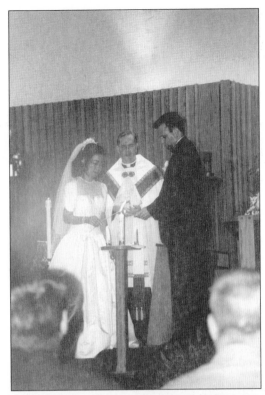

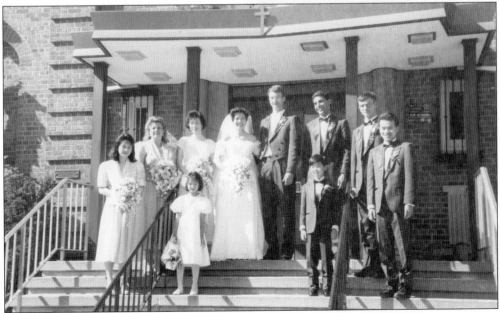

Sonia León (left center) married John Kuenzig (right center) at Our Lady of Grace in Brooklyn.
They held their wedding reception at a Chinese restaurant in Manhattan. After their church
wedding ceremony, the wedding party posed for wedding pictures outside. The wedding party
included León's niece, nephew, sister, brother, and her best friend and Kuenzig's sister and his
two best friends. (Courtesy of Sonia Kuenzig.)

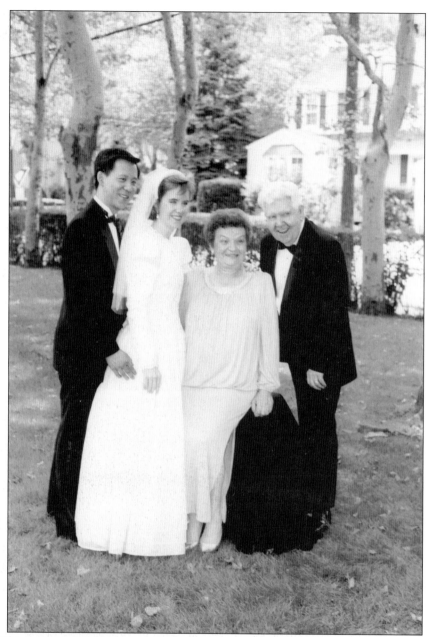

Peter Chian married Kelly Lynn in the presence of family and friends at a Catholic church in Queens. The couple exchanged wedding rings to seal their union. Kelly's family is Irish American and lived in Queens. Outside their wedding reception in Long Island, from left to right, Peter Chian, Kelly Lynn, Margaret Lynn, and Thomas Lynn pose for wedding pictures. Adopting Western traditions, the couple had a traditional white cake with white icing topped with bride and groom figurines. They cut their tiered wedding cake together at their wedding reception and froze the top tier of the cake to eat on their one-year anniversary. The bride wore a traditional white wedding dress with a veil and tossed her flower bouquet. A deejay played dance music. Guests toasted the newlyweds with champagne and offered them well wishes. (Courtesy of Peter Chian.)

The symmetry found in pagodas is characteristic of traditional Chinese architecture. This pagoda-shaped building, pictured in 1968, is located in Kaohsiung City, a large city in Taiwan. The telephone company in New York City installed telephone booths that were decorated with pagoda roofs during the 1970s. (Courtesy of Chu-Ching Hu.)

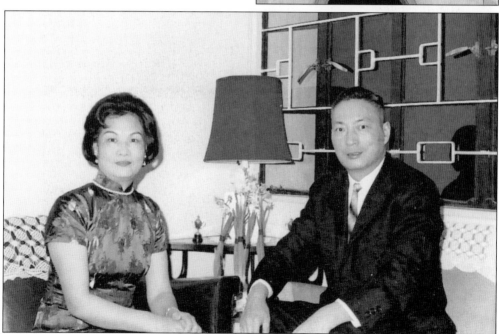

Chu-Ching Hu's grandfather and grandmother sit down next to small white narcissus flowers in 1966. Many Chinese people believe that a flowering narcissus plant during Chinese New Year will bring good luck for the upcoming year. The common daffodil flower is also part of the narcissus genus. (Courtesy of Chu-Ching Hu.)

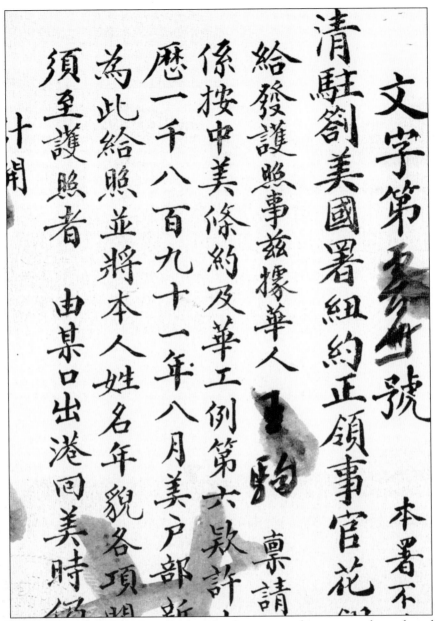

The Chinese language is an extremely complex language to learn to speak, read, and write. It is one written language with thousands of spoken dialects. It is one of the world's oldest written languages and consists of characters. According to the *Practical Chinese Reader*, more than 50,000 Chinese characters exist. Each Chinese character fills a square-shaped area and is created with two building blocks, one signifying the meaning and the other signifying the sound. Spoken Chinese is a tonal language. A Chinese syllable consists of an initial sound, a final sound, and a tone. Syllables pronounced in different tones have differentiated meanings. Cantonese has seven tones while Mandarin has four tones. In Mandarin, the Chinese syllable "ma" in a high tone means "mother," in a high rising tone means "hemp," in a low dipping tone means "horse," and in a high falling tone means "scold." (Courtesy of the National Archives and Records Administration.)

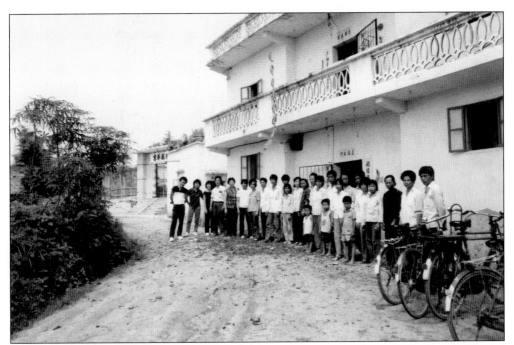

Some Chinese Americans believe that they have an obligation to pay tribute to their family and to strengthen their family ties. Remembering their family, some Chinese Americans return to visit their ancestors' homeland. The León family, pictured here, returned to China for a visit. Firecrackers, used to frighten *gwai* (evil spirits), left behind bits of red wrapping paper. (Courtesy of Benito León.)

Ancestral veneration in China dates back thousands of years. Many Chinese people believe that by honoring their ancestors they acknowledge their family's impact on their lives. They pay homage to their ancestors' accomplishments, memories, and sacrifices. This custom respects a family's past and creates a strong family connection throughout many generations. Ricardo León (far right), pictured here in China, pays his respects at a grave. (Courtesy of Benito León.)

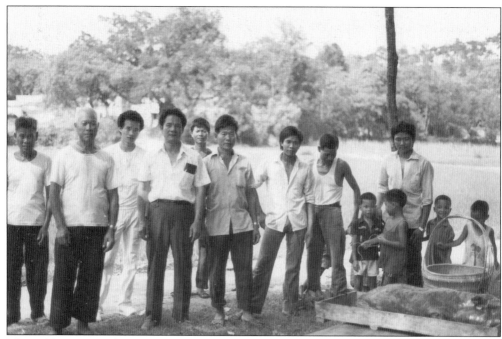

Many Chinese people pay respect to their ancestors by offering food to the spirits of their departed relatives. They bring foods such as *bock chit gai* (poached whole chicken), roasted whole pig, dim sum, pan-fried whole fish, hard boiled eggs, fruit, rice, tea, and whiskey. The León family, pictured here in China, prepares a roasted whole pig. (Courtesy of Benito León.)

Ricardo León burns sticks of incense and bows his head in front of a shrine. He performed this ritual in remembrance of his ancestors. In addition, many Chinese people also burned fake paper money. They carried out this ceremonial practice to present offerings to the spirits of the deceased. (Courtesy of Benito León.)

Tan Dun immigrated to New York City from Hunan, China. While performing research for his multimedia composition *The Map: Concerto for Cello, Video and Orchestra*, he returned to the countryside of China and stood among farmers and cattle in the fields of Western Hunan and reconnected with memories of his past and his cultural heritage. (Courtesy of Tan Dun, Jane Huang and Parnassus Productions.)

Village musicians from Western Hunan hold Lushen, their bamboo pipe instruments. Other traditional Chinese musical instruments dating back thousands of years include the pipa (similar to a lute), the erhu (similar to a violin), and the zheng (similar to a harp). Tan Dun has written musical compositions for pipa, including *Concerto for Pipa and String Orchestra* and *Ghost Opera*. (Courtesy of Tan Dun, Jane Huang and Parnassus Productions.)

Edison Chu (right) visited Taiwan in the 1970s with his family. Born in the United States, Edison traveled to Taiwan for the first time. Trips to their parents' homeland help some Chinese Americans better understand their heritage and bridge the differences between the Chinese and American ways of life. Today Edison often takes business trips to Taiwan. (Courtesy of Edison Chu.)

Thomas Lee's grandmother Leung Yip Sheng lived in this home in the Enping district in China before she immigrated to New York City. After obtaining his college degree, Lee lived in China for one year. He taught English to Chinese students at a university outside of Guangzhou. He traveled throughout China and Hong Kong to learn more about his cultural heritage. (Courtesy of Thomas Lee.)

This village in the Enping district in China contains many rice fields. According to the United States Department of Agriculture, China is the largest rice-producing country in the world and produces a large number of varieties of rice. Many Chinese people eat rice with every meal. (Courtesy of Thomas Lee.)

New York University master of business administration students attended business meetings in Hong Kong during their winter internships. The Chinese Americans took their non-Chinese colleagues for dim sum so that they could absorb the Chinese culture. Some Chinese students pursue higher education for practical reasons. They obtain graduate degrees in fields in which they are most likely to obtain jobs, such as business, medicine, engineering, computer science, and law. (Author's collection.)

Many Chinese people use sandpots to cook braised dishes and soups. A sandpot is an old-fashioned stoneware cooking vessel whose abrasive, gritty outer surface is cream colored and whose smooth inner surface is dark-brown colored. Foods, such as seafood sandpot, are slowly cooked, developing intense flavors. (Courtesy of Chei Lang Chian.)

The wok is the foundation of Chinese culinary culture. Many Chinese people use various cooking techniques with their woks. Woks are versatile and can be used for stir-frying, pan-frying, deep-frying, braising, smoking, boiling, steaming, blanching, and poaching foods. The wok needs to be extremely hot to create the unique essence of stir-frying. (Author's collection.)

Some Chinese Americans plant home vegetable gardens because Chinese vegetables that are *sun seen* (fresh) are essential ingredients in traditional Chinese cooking. Pictured here, Chinese vegetables grow in a family's backyard garden in Brooklyn. The garden contained *foo qwa* (bitter melon), *yeem sai* (cilantro), *gul choy* (Chinese chives), *zeet qwa* (fuzzy melon), *dul gock* (long beans), *fan ke* (tomatoes), and *doong qwa* (winter melon). (Courtesy of Chei Lang Chian.)

Benito León helps his family buy fresh Chinese vegetables in Mexico in the late 1960s. To get fresh vegetables, some Chinese Americans prefer to shop at fruit and vegetable stands in Chinatown rather than at supermarkets. They find the produce in Chinatown to be freshly delivered and prefer not to buy frozen or canned fruits and vegetables. (Courtesy of Benito León.)

Integrating multicultural traditions during the holidays, both Chinese and Western themes emerge in this apartment on Henry Street on the Lower East Side. During Christmastime, a picture of Santa Claus decorated the room along with a picture of the Chinese Star Gods: the God of Happiness, the God of Wealth, and the God of Longevity. (Courtesy of Chei Lang Chian.)

Edison Chu's father, Szu Hsiung Chu, celebrates Christmas in the late 1960s. A Christmas tree with lights and Christmas cards decorate his family's living room. For some Chinese Americans, Christmas is an occasion to spend time with family, whether or not they observe the Christian faith. (Courtesy of Edison Chu.)

Thomas Lee sits next to a Christmas tree, with loads of Christmas presents underneath it, in a living room in Brooklyn in the 1970s. On the evening before Christmas, his family and friends gathered together to celebrate the holiday by having a big dinner and listening to Christmas music. (Courtesy of Thomas Lee.)

Many Chinese people decorate their homes with *tit syuh* (iron plants). This plant rarely flowers. It produces several arching clusters of white fragrant flowers only once or twice in its lifetime and only under atypical conditions. Many Chinese people believe that a flowering iron plant will bring prosperity. (Courtesy of Benito León.)

The Chinese Opera House offered Chinese opera performances. *Dai hay* (Chinese opera) is a form of performing art, accompanied by traditional Chinese musical instruments, that involves singing, dancing, acrobatics, and martial arts. The actors dress in elaborate costumes and wear intricate red and white face makeup. Story lines usually focus on history. (Courtesy of the Library of Congress, Prints and Photographs Division.)

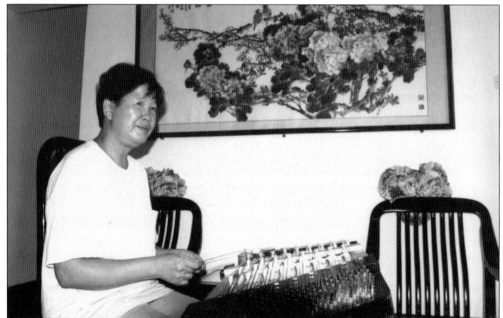

So Kit Chui plays Chinese music on the yangqin in her second home in China. The yangqin is a stringed instrument played with bamboo hammers, similar to a dulcimer. Because Chui has relatives and friends in both China and the United States, she spends time in both her homes in Guangzhou and in New York City. (Courtesy of Kwong Yuen Leung.)

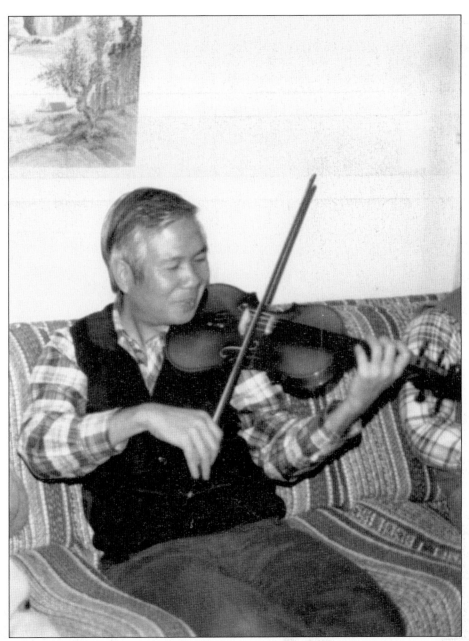

Wing On Leung plays traditional Chinese music on the violin at a family gathering. He provided the accompaniment for his brother-in-law, who sang traditional Chinese love songs. Leung and his relatives shared a passion for Chinese music and enjoyed reminiscing about their mother country through Chinese melodies. They were able to preserve their Chinese culture in New York City with their music. Leung also taught violin lessons to young adults and was a member of the Chinese Music Ensemble of New York. Started in 1961, the ensemble has been performing for more than 45 years. The ensemble originally consisted of only four musicians and has grown to more than 40 musicians. The ensemble is the oldest and largest Chinese orchestra in the United States. It promotes greater awareness of Chinese musical traditions through concerts, lecture-demonstrations, and music lessons. (Courtesy of Kwong Yuen Leung.)

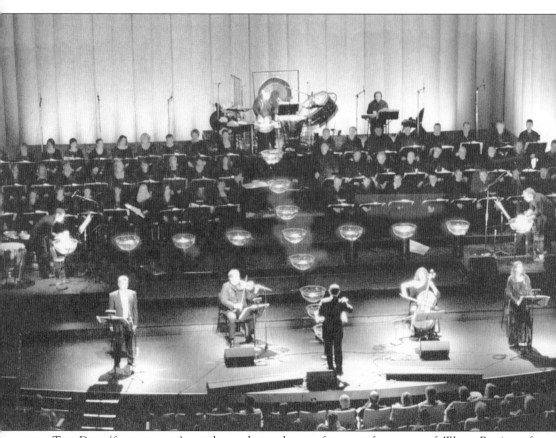

Tan Dun (front, center) conducts the orchestra for a performance of *Water Passion after St. Matthew*. He conducted performances of this masterpiece around the world. The stage was defined by 17 transparent bowls, lit from below, and formed a large cross that separated the playing area for the two choruses, the two soloists, and the two string players. The composition incorporated Western and Chinese musical styles and instruments, including the cello and the xun. The xun is an ancient Chinese ceramic flute with an oval shape. For the performance in London, Tan collaborated with cellist Yo-Yo Ma, a well-known Chinese musical artist from New York. Tan and Ma also collaborated on the multimedia composition *The Map: Concerto for Cello, Video, and Orchestra* and on the soundtrack to the film *Crouching Tiger, Hidden Dragon*. (Courtesy of Hugh Barton, Tan Dun, Jane Huang and Parnassus Productions.)

Growing up in Brazil, Chei Lang Chain incorporated Latin American culture with her Chinese background. Pictured here in a formal dress, she celebrated her 15th birthday with Quinceañera in the 1970s. Family and friends came for this significant fiesta that marks the point in time when a girl becomes a woman. (Courtesy of Chei Lang Chian.)

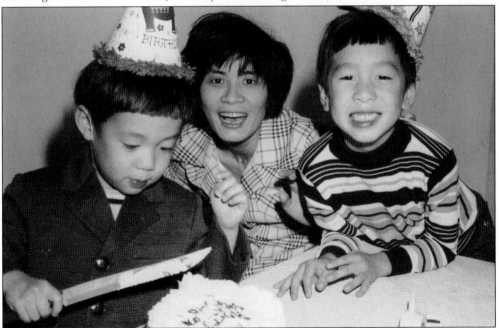

Edison Chu (right), along with his mother Szu Hsiung Chu (center), celebrates his brother's birthday in the 1970s. Traditionally when a Chinese person is born, he or she is considered to be one year old. Therefore, a person's Chinese age is one year more than his or her actual age. (Courtesy of Edison Chu.)

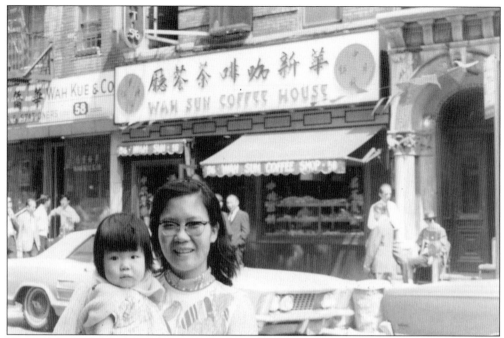

Tsui So Mei (right) and Josephine Lee (left) meet family and friends at Wah Sun Coffee House in Chinatown on a weekend day. After visiting with family and friends in Chinatown, some Chinese Americans would spend time during the weekend to shop for Chinese groceries and roasted meats. (Author's collection.)

Chu-Ching Hu's relatives walked on the trails at Sun Moon Lake in Taiwan in 1968. According to the Taiwanese government, the indigenous Thao people here had pounded grain and sang to summon the spirits of their ancestors. This legendary place is an example of various sources of Chinese folklore that are a part of Chinese culture. (Courtesy of Chu-Ching Hu.)

Six

EDUCATION

Influenced by the teachings of Confucius, many Chinese immigrants believed that education was very important for their children. Typically scholars were highly respected in Chinese culture. In addition, some Chinese American parents had strong hopes for their children to live a better life than they had lived in China. They believed that education would be necessary for their children's success and financial security. Furthermore, they believed that higher education signified status. Therefore, education was crucial to improving their children's future economic standing and social class.

Some Chinese American parents also expected their children to learn the Chinese language and Chinese culture. In addition to attending New York City public schools during the weekdays, some Chinese American children also attended the New York Chinese School and Sunday school on the weekends. Studying long hours, many achieved high grades in both public school and Chinese school. Before long, they discovered American values in public schools and needed to balance them with the Chinese beliefs taught in Chinese school.

Some Chinese American parents wanted their children to graduate from top colleges. They expected their children to do extremely well in school. A large number of Chinese American students attended top New York City public high schools like Stuyvesant High School and the Bronx High School of Science. Graduates from these high schools attended the best universities in the United States.

By graduating from universities, large numbers of Chinese Americans met their parents' goals for them to become well-educated. The United States Census Bureau estimated in 2004 that 50.2 percent of the Chinese population in the United States had earned a bachelor's degree or higher. When compared with 27 percent of the total population holding bachelor's degrees or higher, these figures represented a higher proportion of Chinese Americans holding bachelor's degrees or higher.

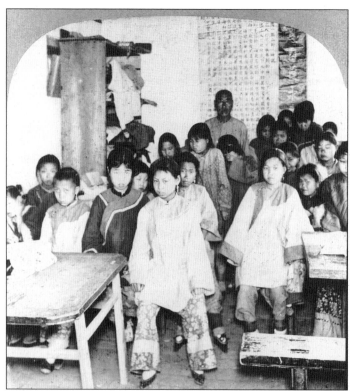

Students at Che-foo pose with a teacher for a *c.* 1902 photograph. Che-foo was a Chinese school for girls located in Yen-t'ai Shih, China. Many Chinese families emphasized the importance of education. Relatives and family friends thought very highly of good grades. (Courtesy of the Library of Congress, Prints and Photographs Division.)

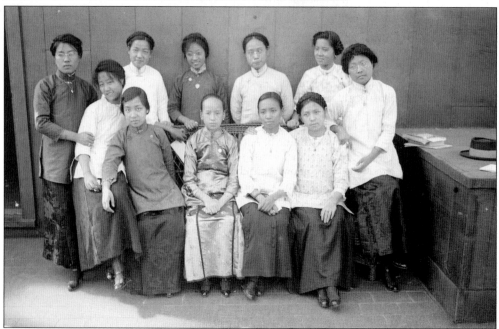

Young Chinese American students pose for a *c.* 1914 photograph in New York City. They wear traditional Chinese clothing. Some Chinese American students required extra time to finish their homework because they could not read or write very well in English yet. (Courtesy of the Library of Congress, Prints and Photographs Division.)

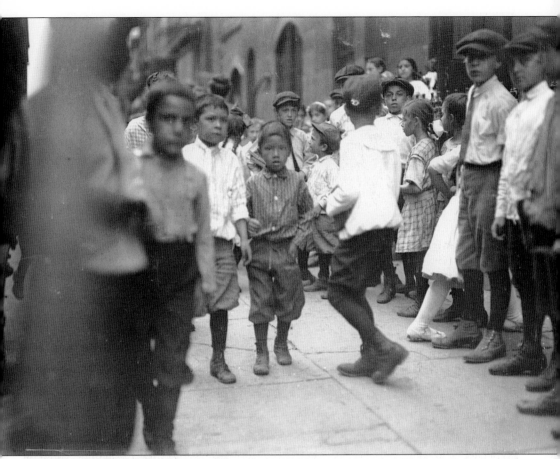

Young schoolchildren, including a Chinese American boy, play together outdoors. Many Chinese American students attended integrated public schools in New York City. Children from immigrant families of different ethnic backgrounds also attended public schools in New York City. Although the other students included Irish, Italian, Russian, German, and French immigrants, they were all Caucasian. This environment confused some Chinese Americans' views about themselves. The expectations of both Eastern and Western cultures overwhelmed some Chinese American children and sometimes caused a lack of self-confidence. Some Chinese American parents did not allow their children to speak English at home. Struggling to preserve their Chinese heritage, some Chinese American parents enrolled their children in Chinese-language schools. Some Chinese American children disliked Chinese lessons and preferred to spend their weekends doing anything else but attend Chinese-language school. (Courtesy of the Library of Congress, Prints and Photographs Division.)

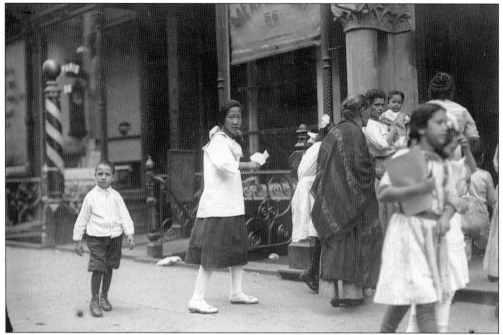

Students, including a Chinese American schoolgirl, walk home at the end of the school day in New York City. A wooden sign that publicized "Rooms to Let" hung in front of her apartment building, which was located next to a barber and a meat market. (Courtesy of the Library of Congress, Prints and Photographs Division.)

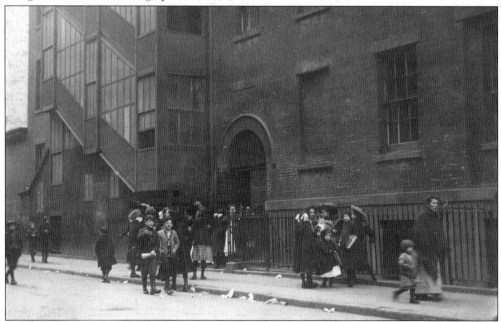

A school on Mott Street in New York City dismisses its students in the afternoon in 1910. Many children, including some Chinese American children, went home to spend the afternoons and evenings helping their parents with work. (Courtesy of the Library of Congress, Prints and Photographs Division, National Child Labor Committee Collection.)

The New York Chinese School (NYCS), founded in 1909 and located at 62 Mott Street in Manhattan's Chinatown, has taught Chinese language and culture classes for nearly a century. Some Chinese American parents feel that it is crucial for their children to learn their native language in order to retain their Chinese heritage. Their children attend NYCS in addition to their regular public schooling. NYCS students learn how to read and write Chinese characters. Classes include the Mandarin and Cantonese dialects and range in grade levels from kindergarten to high school. Classes are taught only in Chinese. In addition to studying the Chinese language, NYCS students also can participate in programs that teach them the fundamentals of traditional Chinese dance, arts and crafts, piano, and drawing. The school also incorporates Chinese history into these programs. Today an increasing number of students in general are interested in learning the Chinese language. According to the Modern Language Association, nearly 35,000 students in 2002 enrolled in Chinese-language classes in United States institutions of higher education. (Courtesy of Chei Lang Chian.)

Chei Lang Chian (right) and her father, Qua Dois Chian (left), pose for pictures after her graduation ceremony at Washington Irving High School in New York City in the 1970s. Like many Chinese American children, Chei Lang also attended Chinese-language classes at NYCS. (Courtesy of Chei Lang Chian.)

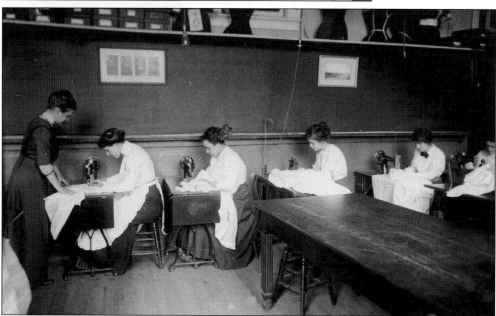

Chei Lang Chian's alma mater, Washington Irving High School, was a public all-girls high school located on Irving Place. Students learned how to use sewing machines to make dollar dresses at Washington Irving in 1911. According to the New York City Department of Education, 16 percent of the high school's students in 2007 were English-language learners. (Courtesy of the Library of Congress, Prints and Photographs Division.)

Peter Chian attended high school in Brooklyn in the early 1980s. While in high school, he read many classic novels for his English classes and learned about themes and symbolism in literature. Pictured here, he was reading Thomas Hardy's *Tess of the D'Urbervilles*, a 19th-century novel about a heroine's tragic destiny. Some Chinese American parents highly valued education. They encouraged their children to attend a top college after graduating from high school. Chian studied very hard in high school and graduated with high honors. He continued studying very hard in college and graduated from a top university in Manhattan. After graduating with a bachelor's degree, he obtained a job in higher education administration. Some Chinese American parents passed on their dreams and aspirations to their children. Chian's academic and professional achievements made his parents extremely proud. (Courtesy of Peter Chian.)

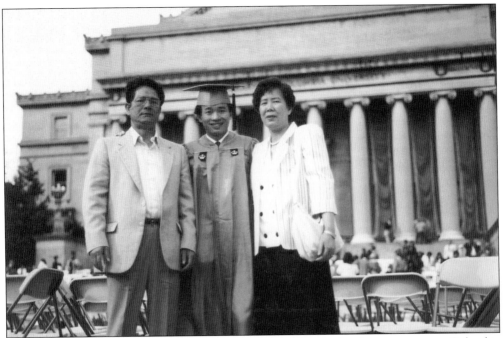

Benito León and his parents take pictures after his college graduation ceremony at Columbia University in the mid-1980s. León was a member of the Chinese Students Club, which promoted greater awareness of Chinese culture on campus. According to statistics at Columbia, nearly 3,000 Asian students enrolled at Columbia in 2005, making up 12 percent of the total student population. (Courtesy of Benito León.)

New York City's first subway, the Interborough Rapid Transit, was completed in 1904. The No. 1 train stopped in front of this platform, whose stairs led to the mezzanine at Columbia University station on 116th Street in Manhattan. (Courtesy of the Library of Congress, Prints and Photographs Division, Historic American Engineering Record.)

Some Chinese American students try hard to achieve their parents' expectations for academic success. They are conscious of the sacrifices that their parents have made for their families and the need to take advantage of the opportunities for a better education. Su Ping Chui (right) stands proud of her son, Benito León (left), for the ribbon awarded to him at school in the 1970s. (Courtesy of Benito León.)

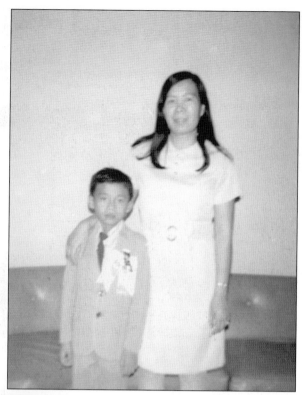

Maria Luisa Burley attended college in New York City and studied business in the early 1980s. Pictured here, she received a bachelor's degree at her graduation ceremony held at Trinity Church. According to the United States Census Bureau, 50.2 percent of the U.S. Chinese population in 2004 had earned a bachelor's degree or higher, compared to 27 percent of the total U.S. population. (Courtesy of Maria Luisa Burley.)

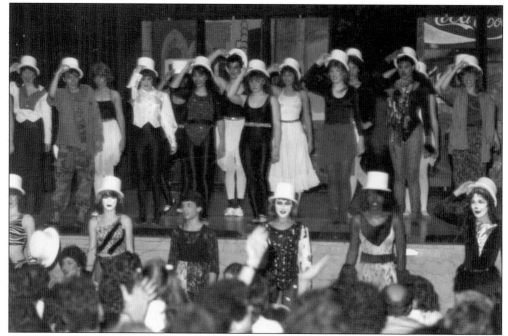

Some Chinese American students participate in a number of after-school extracurricular activities such as math team, newspaper club, drama society, yearbook staff, and debate club. Tulien Aizawa played a role in her high school production of excerpts from Broadway shows, including *Chicago*, *A Chorus Line*, and *Cats*. (Courtesy of Tulien Aizawa.)

Tulien Aizawa (left) and her cousin graduated with honors from a high school in Brooklyn. Many American Chinese families stress the value of education. Family and friends praise good grades and graduating from a top university. Aizawa continued her studies at the University of Pennsylvania and graduated with a college degree in business. (Courtesy of Tulien Aizawa.)

Seven

RECREATION

Many Chinese Americans in New York City involved themselves in both American and Chinese recreational activities. Many enjoyed participating in new hobbies and activities in addition to their traditional pastimes. Integrated schools, mass media, and multicultural marriages exposed Chinese Americans to new ways of life.

Popular American culture surrounded the daily lives of Chinese American young adults, exposing them to new ideas and shaping their thoughts about entertainment. Chinese American parents continued to play mahjong at home, while their children rowed boats in Central Park in Manhattan. They sang traditional Chinese songs, while their children listened to American rock music on records and on New York City's rock radio station WPLJ. They read Chinese-language newspapers, while their children read the *New York Times*. They enjoyed going to the theater to watch Chinese opera, while their children enjoyed going to the cinemas to watch American films. They took visitors to Chinatown, but also to other New York City landmarks, including the Statue of Liberty, Rockefeller Center, the American Museum of Natural History, the New York Aquarium, the New York Botanical Garden, and Coney Island.

Holding onto their ethnic heritage while blending in American culture, many Chinese American lives quickly became ethnically diverse. They faced the challenge of merging old traditional ways with more modern ones. The recreational activities of many Chinese American families continue to evolve as Chinese Americans incorporate different aspects of both Chinese and American culture.

Leung Yip Sheng (left) and Ricardo León (right) play mahjong at a home in Brooklyn. For some Chinese Americans, mahjong is a fundamental aspect of family gatherings. The game play involves assessing probabilities and developing strategies. The game's popularity has spread throughout the world, and mahjong clubs have formed in many countries outside of China. (Courtesy of Benito León.)

Elizabeth Brown (center) spends an afternoon with her family at Columbus Park in Manhattan's Chinatown in the early 1970s. Baxter Street, Worth Street, Bayard Street, and Mulberry Street border the park. Dating back to the 1800s, this multiethnic area has brought together a large number of immigrants, including the Germans, the Irish, and the Italians. (Courtesy of Elizabeth Brown.)

Tulien Aizawa and her cousin enjoy the snow in Brooklyn. Aizawa immigrated to New York City from Vietnam. She had not seen snow before arriving in the United States. The weather in most of Vietnam can be warm, tropical, and rainy, but not freezing cold and snowy. (Courtesy of Tulien Aizawa.)

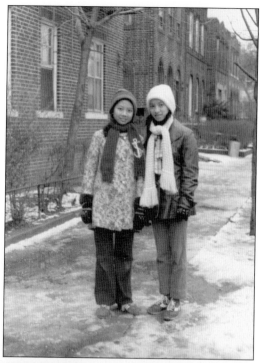

Chei Lang Chian (left) rows a boat in Central Park in the 1970s. The rowboat was vandalized with spray-painted graffiti. Many young adults in New York City, including some Chinese Americans, spent time in Central Park after school and on weekends. They enjoy different outdoor activities, including rowboats, tennis, basketball, and ice-skating. (Courtesy of Chei Lang Chian.)

For more than 150 years, Central Park has been a nature retreat for many New Yorkers, including Chinese Americans. According to the Trust for Public Land, Central Park receives 25 million visits annually and is America's most visited city park as of 2006. Two people, pictured here, walk underneath a footbridge in the fall of 1968. (Courtesy of the Library of Congress, Prints and Photographs Division, Historic American Engineering Record.)

In addition to their schoolwork, some young Chinese Americans took music and dance lessons after school and on weekends. Tulien Aizawa (far right) and some of her classmates at a ballet school warm up with bar exercises. Ballet training requires a lot of hard work and discipline. She spent many hours practicing exercises to keep her body limber for dance performances. (Courtesy of Tulien Aizawa.)

Tulien Aizawa and her mother spend the day shopping in the 1970s. Sales offered clothing for $8 on Avenue J in Brooklyn. Today many Chinese tourists come to New York City to shop for upscale Western brands. They can find lower prices for luxury goods in New York City than in China because the Chinese government levies a high import tax on luxury goods. (Courtesy of Tulien Aizawa.)

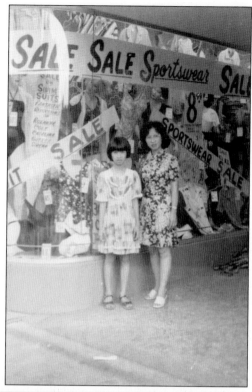

Elizabeth Brown (left) and Josephine Lee (right) play with basketballs at a park in Chinatown in the 1970s. The graffiti spray painted on the concrete walls said "Imperial Dragons Terf Keep Out." Today the New York Police Department offers rewards of up to $500 for information leading to the arrest and conviction of graffiti vandals. (Courtesy of Elizabeth Brown.)

Growing up in Brooklyn in the 1970s, Peter Chian (right) enjoyed watching and playing American sports. He attended New York Mets baseball games and often practiced swinging at pitches during visits with family. Although baseball has been the American pastime since the mid-1800s, the first professional baseball league in China started in 2004. (Courtesy of Peter Chian.)

Chian immigrated to New York City from Brazil, where the weather was always warm. He saw snow for the first time in the 1970s. School closed for the snowstorm. Taking a break from shoveling snow, he rides on a sled pulled by one of his brothers. (Courtesy of Peter Chian.)

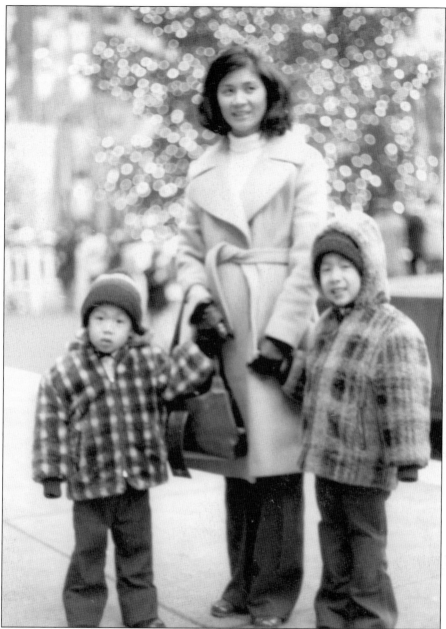

In December, Edison Chu (right) visited Rockefeller Center in Manhattan in the 1970s with his family. Some Chinese Americans enjoy taking walks in midtown during the wintertime. They view the beautifully lit Christmas tree, look at the elaborate window displays of Fifth Avenue department stores, and watch the crowds of ice-skaters go around in circles on the outdoor ice-skating rink. The first Christmas tree placed at Rockefeller Center in 1931 was undecorated. Today more than 25,000 multicolored miniature bulbs and a star decorate the tree. Some Chinese Americans, even those who are not Christian, enjoy the Christmas holiday season. They write greeting cards, decorate fir trees, put up strings of blinking lights, hang holly, sing Christmas carols, host Christmas parties, visit family, and exchange Christmas gifts. (Courtesy of Edison Chu.)

Benito León immigrated to New York City from Mexico, where the weather was always warm. He enjoyed playing in the snow for the first time in the 1970s. He built a large fort with blocks of snow in order to defend himself in a snowball fight against his sisters. (Courtesy of Benito León.)

American popular culture influenced the way some Chinese American children spent their free time. Edison Chu (left) and his friend enjoyed looking at reels in the 1970s with the View-Master, a stereograph viewer. His early interest in technological gadgets steered him toward obtaining his bachelor's degree in engineering. (Courtesy of Edison Chu.)

In addition to photography equipment, Chu had an interest in other technical devices, such as the phonograph. Pictured here in the 1970s, he enjoyed listening to music on his records. By the 1980s, record players became outdated technology with the development of compact disc players. Years later, Chu found a job in Manhattan where he continued to explore his interest in technologies. (Courtesy of Edison Chu.)

Tsui So Mei visits the New York Botanical Garden in the Bronx in the late 1960s. This Victorian glasshouse is home to a variety of flowers and plants. There is a rose garden, a perennial garden, and a rock garden on the grounds. The plant collection includes orchids, daylilies, conifers, and flowering trees. (Author's collection.)

Tsui So Mei reads a Chinese-language newspaper during dim sum at a restaurant in Chinatown. She preferred reading a Chinese-language newspaper even though she could read English. Chinese newspapers helped keep Chinese immigrants informed about news in their community and the rest of the United States written from a Chinese reporter's perspective. Some Chinese Americans took visitors to *yum cha* (drink tea) and eat dim sum. Dim sum consists of small dishes of food and is served until the late afternoon. Many customers at dim sum request *bolay* tea, which is valued as a tonic and an aid to digestion. Popular dishes include *jook* (rice porridge, usually with thousand-year-old eggs), *har gow* (steamed shrimp dumplings), *siu mai* (steamed pork dumplings), *no mai gai* (sticky rice and meat wrapped with a lotus leaf), *wu gok* (fried mashed taro root), *cheon gyun* (spring rolls), *dou fu fa* (silky tofu with sweet syrup), *fung jau* (chicken feet), and *pai gwat* (steamed spare ribs with black beans). (Author's collection.)

Tulien Aizawa rides the Circle Line ferryboat to visit the Statue of Liberty in the 1970s. Both tourists and resident New Yorkers, including many Chinese Americans, take the ferry through New York Harbor to view the statue, visit Liberty Island, and climb the 154 steps from the statue's pedestal to the statue's head. (Courtesy of Tulien Aizawa.)

Yu Man Chu passes the time at Battery Park while waiting to take the Circle Line ferryboat to the Statue of Liberty around 1970. The ferryboats take hundreds of passengers daily from Battery Park in New York and Liberty State Park in New Jersey to visit the statue on Liberty Island. (Courtesy of Edison Chu.)

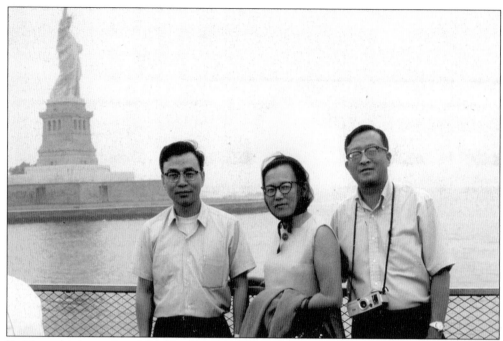

Yu Man Chu (center) and Szu Hsiung Chu (left) took a visitor to see many of New York City's tourist attractions in the 1970s, including the Statue of Liberty. Approaching the sights from the Circle Line ferryboat gave them photograph opportunities with great views of the statue. (Courtesy of Edison Chu.)

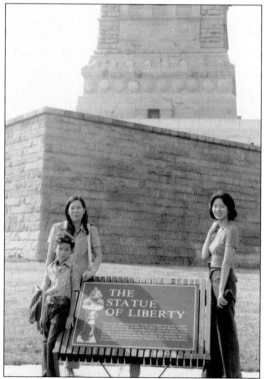

From left to right, Benito León, Su Ping Chui, and Ana León visit the Statue of Liberty National Monument in the 1970s. The Statue of Liberty is more than just a landmark stop for New York City tourists. It is a symbol of hope and freedom for people around the world. (Courtesy of Benito León.)

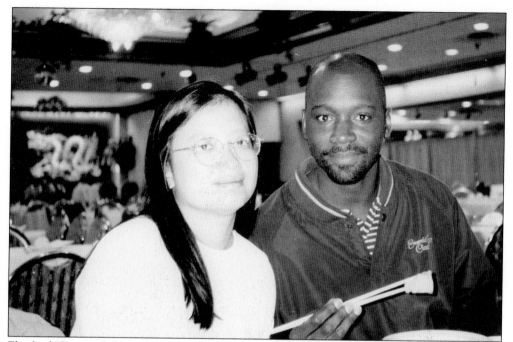

Elizabeth Brown (left) took her husband Joseph Brown III (right) for dim sum in Manhattan's Chinatown and taught him how to use chopsticks. A golden dragon hung on the wall in the background. Dragons are found in many aspects of Chinese culture. Some Chinese Americans believe that dragons protect people against evil spirits and bring good fortune. (Courtesy of Elizabeth Brown.)

Tulien Aizawa and her family spent a day at the American Museum of Natural History in Manhattan in the 1970s. They learned about dinosaur fossils. Some Chinese American parents would take their children to this museum to learn about the natural sciences, including the planets, meteorites, ocean life, and dinosaurs. (Courtesy of Tulien Aizawa.)

Thomas Lee waits at the passenger pick up area at John F. Kennedy Airport in Brooklyn for his relatives to deplane a Trans World Airlines flight. His entire family would make the trip to the airport to greet visiting relatives as well as send them off at the end of their vacation. (Courtesy of Thomas Lee.)

Lee and his family visited the New York Aquarium in Brooklyn in the 1970s. He enjoyed looking at the fish and marine animals, which included dolphins, sharks, walruses, and beluga whales. He wore a New York Yankees hat. Like many other American children, some Chinese American youths were baseball fans. (Courtesy of Thomas Lee.)

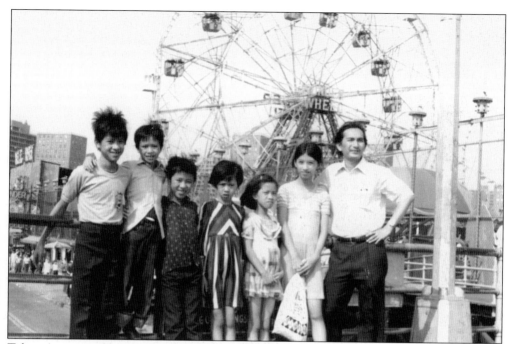

Tulien Aizawa and her family spent a day at Coney Island in the 1970s. The Chinatown in the Avenue U-Marine Park section of Brooklyn is near Coney Island. Some Chinese Americans would go there to walk on the boardwalk, play skeeball, ride the bumper cars, enjoy the beach, or visit the New York Aquarium. (Courtesy of Tulien Aizawa.)

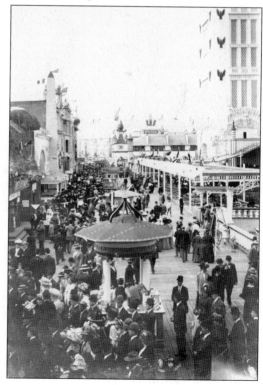

Coney Island is a New York City historic landmark featuring rides, attractions, and a beach. Pictured here is Dreamland at Coney Island between 1908 and 1915. People of all ages came to Coney Island to escape their hectic, daily city lives. (Courtesy of the Library of Congress, Prints and Photographs Division.)

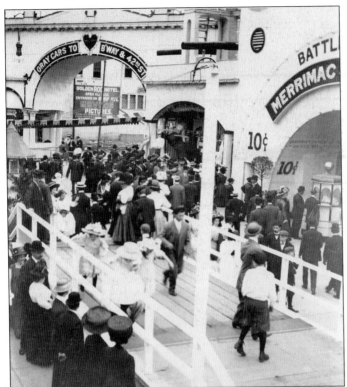

Crowds of people stroll along the boardwalk at Coney Island between 1908 and 1915. People of various ages and different economic backgrounds came to this small area in Brooklyn to enjoy its fun atmosphere. Nathan's famous hot dogs began at Coney Island. (Courtesy of the Library of Congress, Prints and Photographs Division.)

Elizabeth Brown plays with a soccer ball outside her aunt's house in Brooklyn in the 1970s. She and her family spent the weekends visiting their aunts, uncles, cousins, and grandparents. The older generation played mahjong indoors while the younger generation played sports outdoors. (Courtesy of Elizabeth Brown.)

Chei Lang Chian takes in the sun at a playground near her family's apartment in Chinatown in the 1970s. Retaining her Chinese heritage while embracing American culture, she wore a traditional Chinese red embroidered silk jacket with denim jeans and athletic shoes. She and her brothers often played basketball here. (Courtesy of Chei Lang Chian.)

Edison Chu (right) enjoys some Italian ice at a park in the 1970s. Italian ice is commonly found throughout New York City in Italian shops and at pushcart vendors. A variety of flavors are available, including cherry, mango, lime, banana, coconut, orange, and lemon. (Courtesy of Edison Chu.)

BIBLIOGRAPHY

The American Community—Asians: 2004. Washington, D.C.: United States Census Bureau, 2007.

Bellafaire, Judith. "Asian-Pacific-American Servicewomen in Defense of a Nation." Women in Military Service for America Memorial Foundation, Inc. www.womensmemorial.org/Education/APA.html. 1999.

Chang, Iris. *The Chinese in America: A Narrative History.* New York: Viking, 2003.

Chinatown One Year after September 11th: An Economic Impact Study. New York: Asian American Federation of New York, 2002.

Hall, Bruce Edward. *Tea That Burns: A Family Memoir of Chinatown.* New York: Free Press, 1998.

Hansen, James, Frank Fuller, Frederick Gale, Frederick Crook, Eric Wailes, and Michelle Moore. "China's Japonica Rice Market: Growth and Competitiveness." *Rice Situation and Outlook Yearbook.* Washington, D.C.: United States Department of Agriculture, 2002.

Kwong, Peter. *Chinatown, N.Y.: Labor and Politics, 1930–1950.* Rev. ed. New York: New Press, 2001.

Kwong, Peter, and Dusanka Miscevic. *Chinese America: The Untold Story of America's Oldest New Community.* New York: New Press, 2006.

Liu, Eric. *The Accidental Asian: Notes of a Native Speaker.* New York: Random House, 1998.

Lo, Amy. *The Book of Mahjong: An Illustrated Guide.* Boston: Tuttle Publishing, 2001.

Practical Chinese Reader: Elementary Course Book I. Beijing: Commercial Press, 1989.

"Sigel Suspects Traced to West: Believed to Have Been Seen Successively in Philadelphia, Washington, and Chicago." *New York Times,* June 21, 1909: 1.

Tsai, Shih-Shan Henry. *The Chinese Experience in America.* Bloomington, IN: Indiana University Press, 1986.

Welles, Elizabeth B. "Foreign Language Enrollments in United States Institutions of Higher Education, Fall 2002." *Association of Departments of Foreign Languages Bulletin.* 35 (2004): 7-26.

Young, Grace. *The Wisdom of the Chinese Kitchen: Classic Family Recipes for Celebration and Healing.* New York: Simon and Schuster Editions, 1999.

INDEX

ACROSS AMERICA, PEOPLE ARE DISCOVERING SOMETHING WONDERFUL. *THEIR HERITAGE.*

Arcadia Publishing is the leading local history publisher in the United States. With more than 3,000 titles in print and hundreds of new titles released every year, Arcadia has extensive specialized experience chronicling the history of communities and celebrating America's hidden stories, bringing to life the people, places, and events from the past. To discover the history of other communities across the nation, please visit:

www.arcadiapublishing.com

Customized search tools allow you to find regional history books about the town where you grew up, the cities where your friends and family live, the town where your parents met, or even that retirement spot you've been dreaming about.